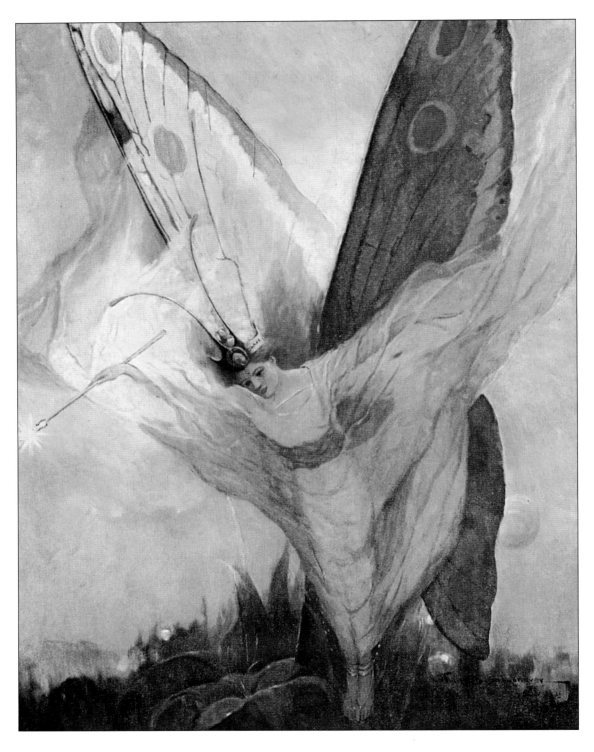

Frontispiece
Cover plate from *Hans Andersen's Fairy Tales and Wonder Stories*
FRANK SCHOONOVER, 1914

Once Upon a Time...

A Treasury of Classic
Fairy Tale Illustrations

Selected and Edited by Jeff A. Menges

Dover Publications, Inc.,
Mineola, New York

Bibliographical Note

This Dover edition, first published in 2008, is an original compilation of illustrations from the following sources: Elenore Abbott, *Grimm's Fairy Tales* (Charles Scribner's Sons, New York, 1920) and *The Wild Swans and Other Stories* (George W. Jacobs & Company, Philadelphia,1922); Mabel Lucie Attwell, *Hans Andersen's Fairy Tales* (Raphael Tuck & Sons, Ltd., London and New York, 1914); A. Duncan Carse, *Hans Andersen's Fairy Tales* (Adam and Charles Black, London, 1912); Harry Clarke, *Fairy Tales from Hans Andersen* (Harrap, London, 1916); Herbert Cole, *Fairy-Gold, A Book of Old English Fairy Tales* (J. M. Dent & Sons, Ltd., London, 1906); Walter Crane, *Household Stories by the Brothers Grimm* (Macmillan and Co., New York, 1882) and *Goody Two Shoes' Picture Book* (George Routledge and Sons, London and New York, 1901); Gustave Doré, *Les Contes de Perrault* (J. Hetzel, Librarie-Editeur, Paris, 1867); Edmund Dulac, *The Sleeping Beauty and Other Fairy Tales* (Hodder & Stoughton, Ltd., 1911) and *Stories from Hans Andersen* (Hodder & Stoughton, Ltd., London, 1912); Charles Folkard, *Grimm's Fairy Tales* (A. & C. Black, London, 1911); H. J. Ford, *The Green Fairy Book* (Longmans & Company, London, 1892), *The Book of Romance* (Longmans, 1903), *The Crimson Fairy Book* (Longmans, 1903), *The Brown Fairy Book* (Longmans, 1904), and *The Red Book of Romance* (Longmans, 1905); Warwick Goble, *The Fairy Book; The Best Popular Stories Selected and Rendered Anew* (Macmillan and Co., Ltd., London, 1913); Reginald Knowles, *Norse Fairy Tales* (S. T. Freemantle, London, 1910); Kay Nielsen, *East of the Sun and West of the Moon* (Hodder & Stoughton, London, 1914) and *In Powder and Crinoline* (Hodder & Stoughton, London, 1913); Noel Pocock, *Grimm's Fairy Tales* (Hodder & Stoughton, New York, n.d.); Arthur Rackham, *The Allies' Fairy Book* (William Heinemann, London, 1916), *English Fairy Tales* (Macmillan and Co., Ltd., London, 1918), *Snowdrop and Other Tales by the Brothers Grimm* (Constable & Co., London, 1920), and *Hansel and Grethel and Other Tales by the Brothers Grimm* (Constable & Co., London, 1920); Louis Rhead, *Hans Andersen's Fairy Tales and Wonder Stories* (Harper & Bros., New York and London, 1914); William Heath Robinson, *Hans Andersen's Fairy Tales* (Constable & Co., London, 1913); Charles Robinson, *The Happy Prince and Other Tales by Oscar Wilde* (Duckworth & Co., London, 1913); Frank Schoonover, *Hans Andersen's Fairy Tales and Wonder Stories* (Harper & Brothers, New York and London, 1914); Helen Stratton, *The Fairy Tales of Hans Christian Andersen* (Truslove, Hanson & Comba, Ltd., London, 1899); Hans Tegner, *Fairy Tales and Stories by Hans Christian Andersen* (The Century Co., New York, 1900); Gustaf Tenggren, *D'Aulnoy's Fairy Tales* (David McKay Company, Philadelphia, 1923); and Milo Winter, *Hans Andersen's Fairy Tales*, (Rand McNally & Company, Chicago, 1916).

Library of Congress Cataloging-in-Publication Data

Once upon a time— a treasury of classic fairy tale illustrations / selected and edited by Jeff A. Menges.
 p. cm.
 ISBN-13: 978-0-486-46830-3
 ISBN-10: 0-486-46830-5
 1. Fairy tales—Illustrations. 2. Children's literature—Illustrations. 3. Illustrated children's books. I. Menges, Jeff A.

NC965.7.F35053 2008
741.6'42—dc22

2008037654

46830502 2014
Printed in China by R.R. Donnelley
www.doverpublications.com

To Natalie Grace

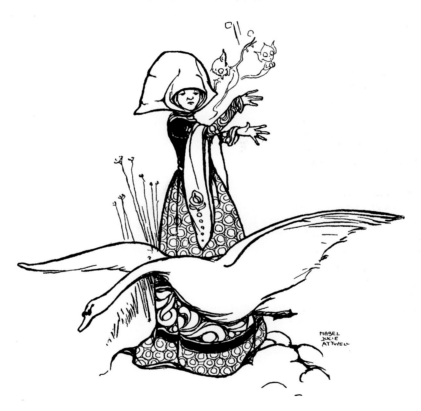

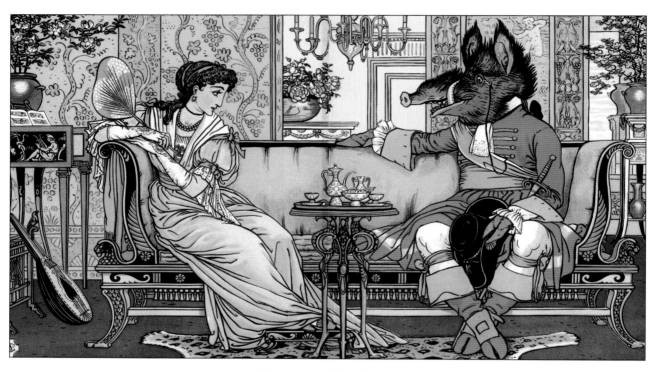

Beauty and the Beast

"Beauty and the Beast," *Goody Two Shoes' Picture Book*
WALTER CRANE, 1901

Introduction

Fairy tales—popular the world over—are stories of extraordinary events whose purpose is to both entertain, and educate, the young and young-at-heart. Often, a tale concludes with a moral, or offers a life-lesson, giving some added value to an elder who takes the time to share the tale with a young one. Nothing is more valuable, however, to the appreciation of a fairy tale than illustrations: although reading to a child about a cavern filled with sparkling riches or a magician's robe embroidered with magical patterns, or—as seen on these very pages—a beast dressed in princely garments sets the mind to imagining, showing that same reader (or listener) a well-rendered image further pushes the mind to create its own scenes of the tale. Illustrations also produce the effect of involvement. Standing outside of a scene, but being able to observe its details, makes the reader a witness as well. Illustration has always been an important component of books, beginning with the earliest forms of manuscripts. In the books being produced today, there is no place where illustration is stronger than in

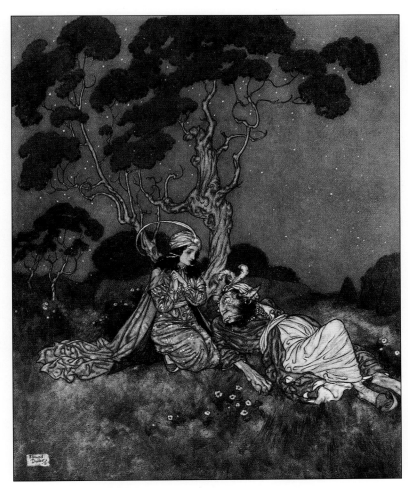

"ah! what a fright you have given me!" she murmured

"Beauty and the Beast," *The Sleeping Beauty and Other Tales*
Edmund Dulac, 1910

tales of the imagination. And within this genre, no story holds a broader appeal than a fairy tale.

At the turn of the last century, when full-color printing was a novel phenomenon and reading was one of the most readily available and affordable forms of entertainment, large publishing houses created the "gift-book." Most of the illustrations in this volume come from such books. Gift-books were large, extravagantly produced volumes possessing large numbers of color illustrations, usually printed on separate plates that were hand-tipped to the text stock. These volumes became something to look forward to at the holidays, and by the time that the first decade of the twentieth century was over, nearly every major publisher was producing

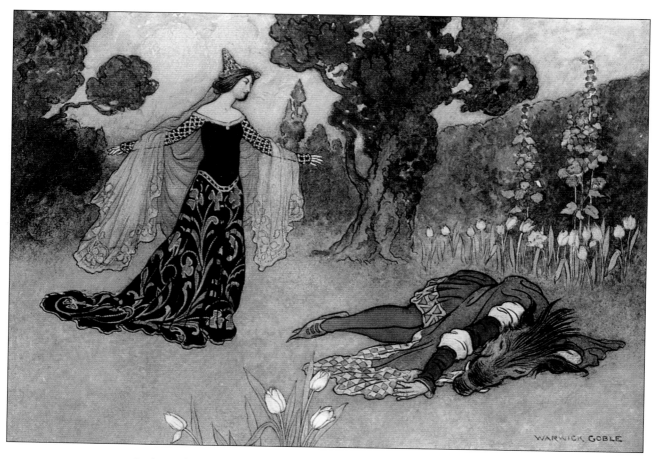

**At last she remembered her dream, rushed to the grass-plot,
and saw him lying there apparently dead**

"Beauty and the Beast," *The Fairy Book: The Best Popular Fairy Stories Selected and Rendered Anew*
WARWICK GOBLE, 1913

its prized title in a "gift-book" edition. The best illustrators were, in fact, commodities prized by each publishing house—publishers became aware that the buying public would eagerly await the next book from their favorite illustrator.

More than any other type, the book of choice for gift-book publishing was the fairy tale. The public was already familiar with and appreciative of these stories, and the books were something that every youngster would welcome into a growing home library. The size, mass, and quality of these editions helped add to their longevity, and they often survived to be handed down to the next generation of young readers in the family—warming the hearts of parents who had read the tales and enjoyed their illustrations when they themselves were children.

There is a common ground shared by fairy tales. They have been told in scores of languages and by thousands of storytellers. Fairy tales have a way of transcending boundaries, because they entertain with lessons that apply to all people and all cultures. Many of the scenes depicted within the pages of the present edition will strike readers as familiar, even if the specific illustrations are not. While the tales—having been

impressed upon us at a young age—travel with us in our memories, what often makes the most and lasting impression are the images that accompany them. For example, we all carry an idea of "the beast" in our minds, and the one that we imagine is probably the one we have seen the most.

Gathered here in these pages are many of the dreams, and possibly a nightmare or two, lovingly depicted by a handful of artists who skillfully, and exquisitely, combined the skills of visual storytelling and design. Some of the artistic styles are unique, while others followed popular trends, but all twenty-three illustrators included in *Once Upon a Time* brought another dimension to these beloved stories. Their own creative visions and interpretations have left vivid impressions on generation after generation.

Jeff A. Menges
August 2008

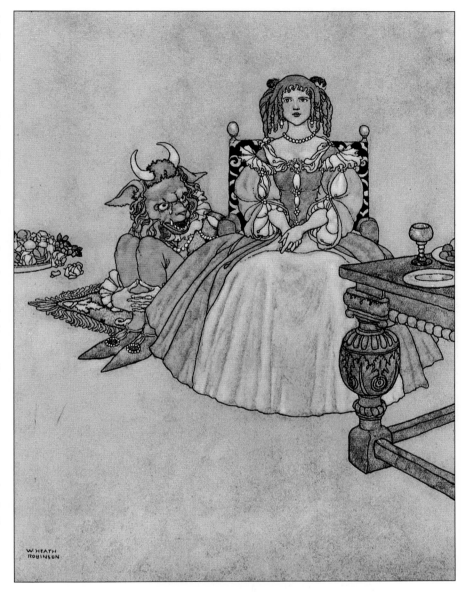

Every evening the beast paid her a visit
"Beauty and the Beast," Old Time Stories by Charles Perrault
W. Heath Robinson, 1921

ix

Selected Bibliography

Dalby, Richard. *The Golden Age of Children's Book Illustration.*
 Michael O'Mara Books Limited, 1991.

Elzea, Rowland, and Hawkes, Elizabeth H. (eds.) *A Small
 School of Art: the Students of Howard Pyle.* Delaware Art
 Museum, 1980.

Larkin, David (ed.) *Charles and William Heath Robinson.*
 Constable, 1976.

Meyer, Susan. *A Treasury of the Great Children's Book Illustrators.*
 Harry N. Abrams, Inc., 1983.

Peppin, Brigid. *Fantasy: Book Illustration 1860-1920.*
 Cassell & Collier Macmillan Publishers Limited, 1975

Vadeboncouer, Jim. "Illustrator Biographies" Bud Plant
 Illustrated Books, July 4, 2008.
 http://www.bpib.com/illustra.htm

Worth, Stephen. ASIFA-Hollywood Animation Archive
 August 1, 2008.
 http://www.animationarchive.org/labels/animal.html

Artists and Volumes

FRONTISPIECE

FRANK SCHOONOVER, Cover plate for *Hans Andersen's Fairy Tales and Wonder Stories*, Harper & Brothers, New York and London, 1914

INTRODUCTION (Beauty and the Beast plates)

WALTER CRANE, *Goody Two Shoes' Picture Book*, George Routledge and Sons, London and New York, 1901

EDMUND DULAC, *The Sleeping Beauty and Other Tales*, Hodder & Stoughton, Ltd., London, 1910

WARWICK GOBLE, *The Fairy Book; The Best Popular Fairy Stories Selected and Rendered Anew*, Macmillan and Co., Ltd., London, 1913

WILLIAM HEATH ROBINSON, *Old Time Stories* by Charles Perrault, Dodd, Mead, New York, 1921

1. ELENORE ABBOTT (1875–1935)
 Grimm's Fairy Tales, Charles Scribner's Sons, New York, 1920
 The Wild Swans and Other Stories, George W. Jacobs & Company, Philadelphia, 1922

9. MABEL LUCIE ATTWELL (1879–1964)
 Hans Andersen's Fairy Tales, Raphael Tuck & Sons, Ltd., London, Paris, Berlin, New York, Montreal, 1914

17. A. DUNCAN CARSE (1876–1938)
 Hans Andersen's Fairy Tales, Adam and Charles Black, London, 1912

25. HARRY CLARKE (1889–1931)
 Fairy Tales from Hans Andersen, J. Coker, & Co., Ltd., London, 1916

31. HERBERT COLE (1867–1930)
 Fairy-Gold, A Book of Old English Fairy Tales, J. M. Dent & Sons Ltd., London, 1906

41. WALTER CRANE (1845–1915)
 Household Stories by the Brothers Grimm, Macmillan and Co., New York, 1882
 Goody Two Shoes' Picture Book, George Routledge and Sons, London and New York, 1901

51. GUSTAVE DORÉ (1832–1883)
 Les Contes de Perrault, J. Hetzel, Libraire-Édituer, Paris, 1867

57. EDMUND DULAC (1882–1953)
 The Sleeping Beauty and Other Fairy Tales, Hodder & Stoughton, Ltd., London, 1910
 Stories from Hans Andersen, Hodder & Stoughton, Ltd., London, 1911

67. CHARLES FOLKARD (1878–1963)
 Grimm's Fairy Tales, A. & C. Black, London, 1911

(continued)

The Plates

Opposite: **The king's daughter had been carried away by a dragon**

"The Four Accomplished Brothers," *Grimm's Fairy Tales*
ELENORE ABBOTT, 1920

Elenore Abbott, 1875-1935
Grimm's Fairy Tales, 1920
The Wild Swans and Other Stories, 1922

Elenore Plaisted Abbott was born in Maine. She studied in Philadelphia and Paris, and was one of a handful of American illustrators who had the good fortune to study with acclaimed commercial illustrator Howard Pyle, who was a professor at Drexel University at the turn of the century. Abbott developed a strong career in the illustration of books (such as *Grimm's Fairy Tales* and *Swiss Family Robinson*) and magazines (*Saturday Evening Post* and *Scribner's*, among others). She painted images for many stories, and fairy tales were a favorite subject.

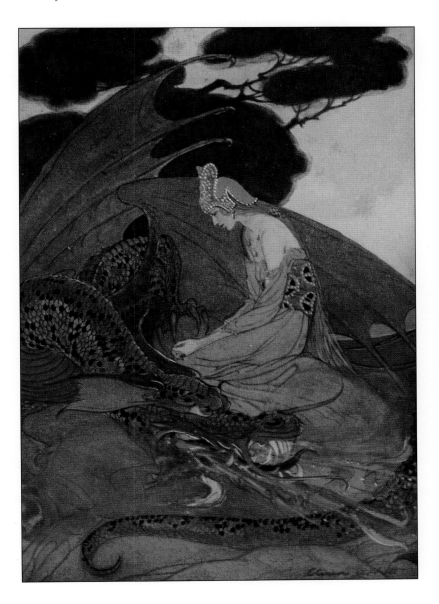

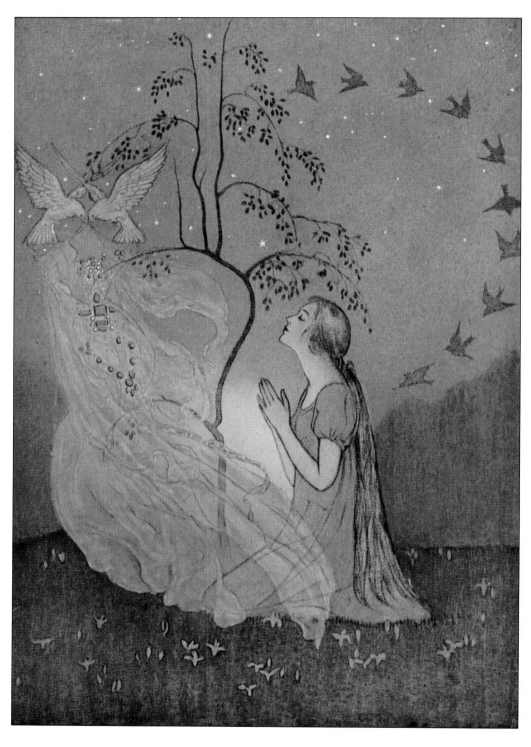

"Rustle and shake yourself, dear tree, And silver and gold throw down to me"

"Cinderella," Grimm's Fairy Tales
ELENORE ABBOTT, 1920

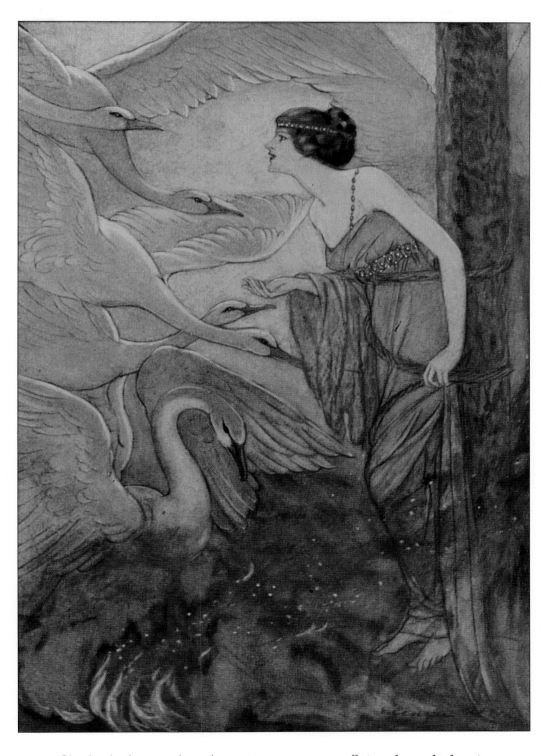

She looked around, and saw six swans come flying through the air

"The Six Swans," *Grimm's Fairy Tales*
ELENORE ABBOTT, 1920

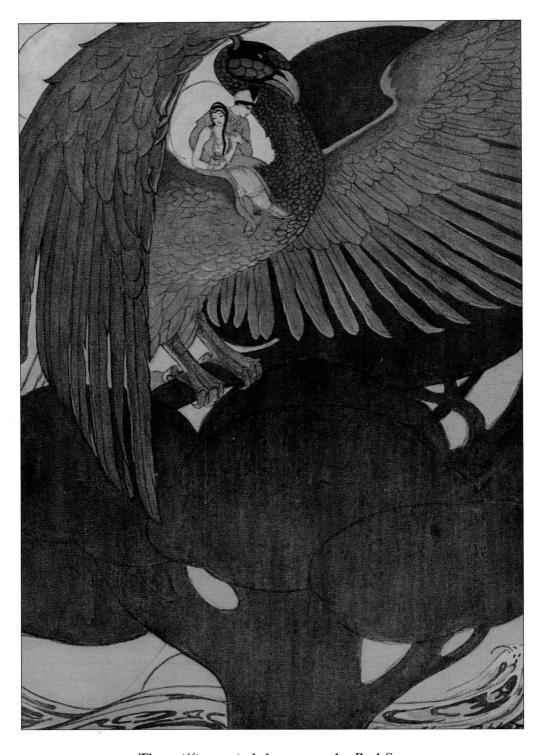

The griffin carried them over the Red Sea

"The Soaring Lark," Grimm's Fairy Tales
Elenore Abbott, 1920

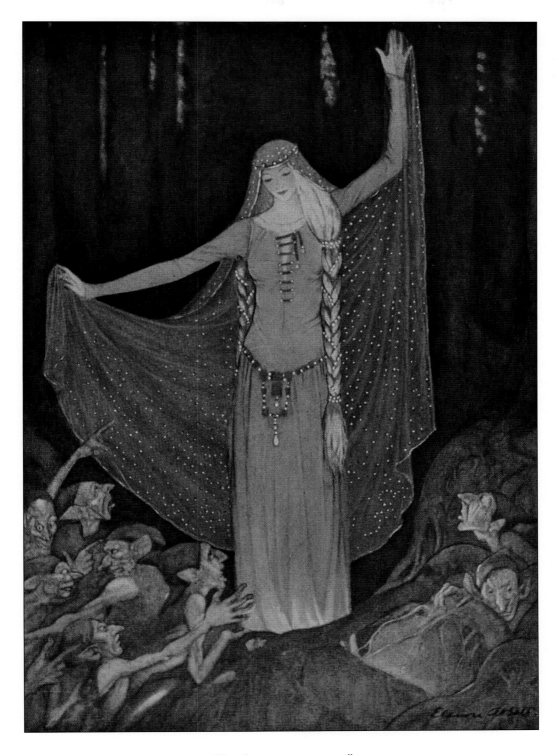

"Earthmen, come up!"

"The Two King's Children," *Grimm's Fairy Tales*
ELENORE ABBOTT, 1920

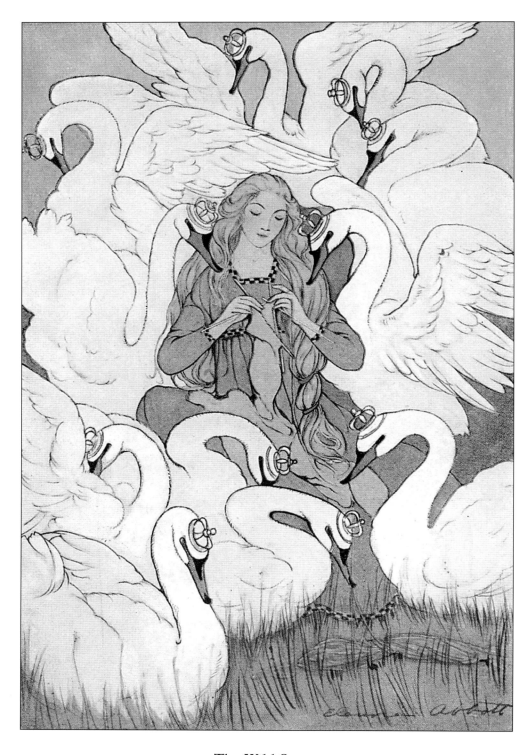

The Wild Swans

The Wild Swans and Other Stories
ELENORE ABBOTT, 1922

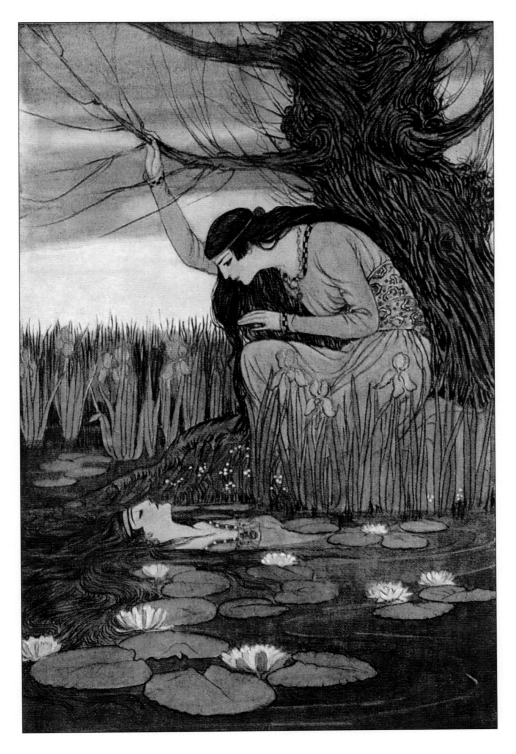

The Marsh King's Daughter

The Wild Swans and Other Stories
ELENORE ABBOTT, 1922

Opposite: **The Red Shoes**
"The Red Shoes," *Hans Andersen's Fairy Tales*
Mabel Lucie Attwell, 1914

MABEL LUCIE ATTWELL, 1873-1964
Hans Andersen's Fairy Tales, 1914

A successful artist whose work appeared in magazines, advertisements, and children's books, British illustrator Mabel Attwell developed a visual "trademark" in her depiction of children—the cherub—that made her work instantly recognizable. This imagery served her well, as her work found applications in varied markets and products, from calendars to dolls to nursery items. Attwell's illustrations appeared in a long list of children's literature that we regard as classics today, including such tales as Charles Kingsley's *Water Babies* and Lewis Carroll's *Alice in Wonderland*. J. M. Barrie himself requested that Attwell illustrate a gift edition of *Peter Pan and Wendy* in 1921.

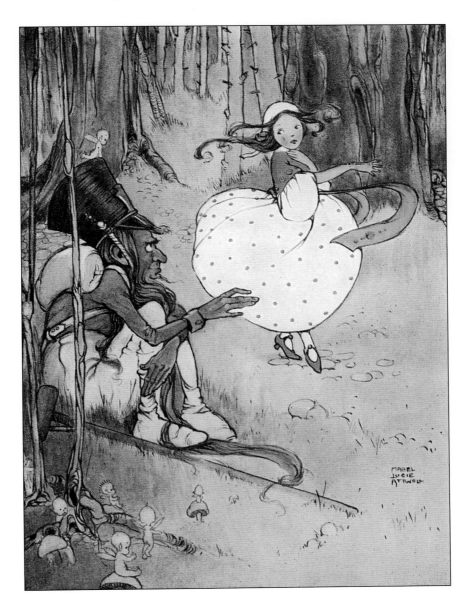

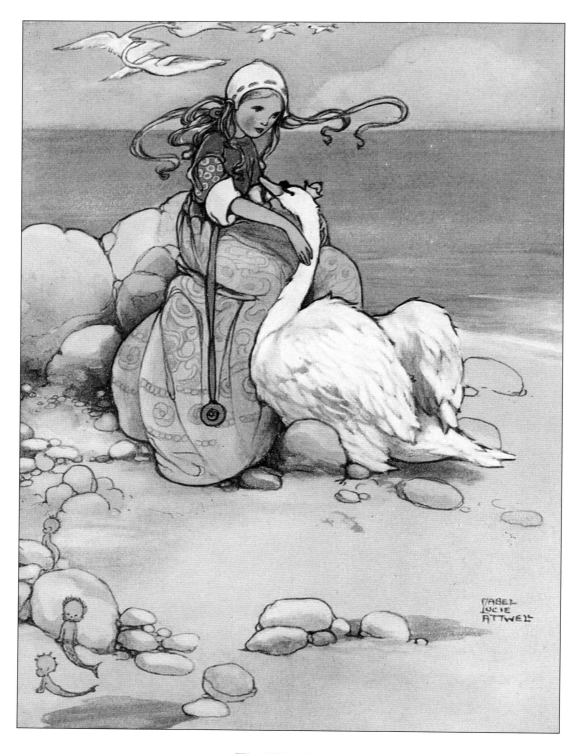

The Wild Swans

"The Wild Swans," *Hans Andersen's Fairy Tales*
MABEL LUCIE ATTWELL, 1914

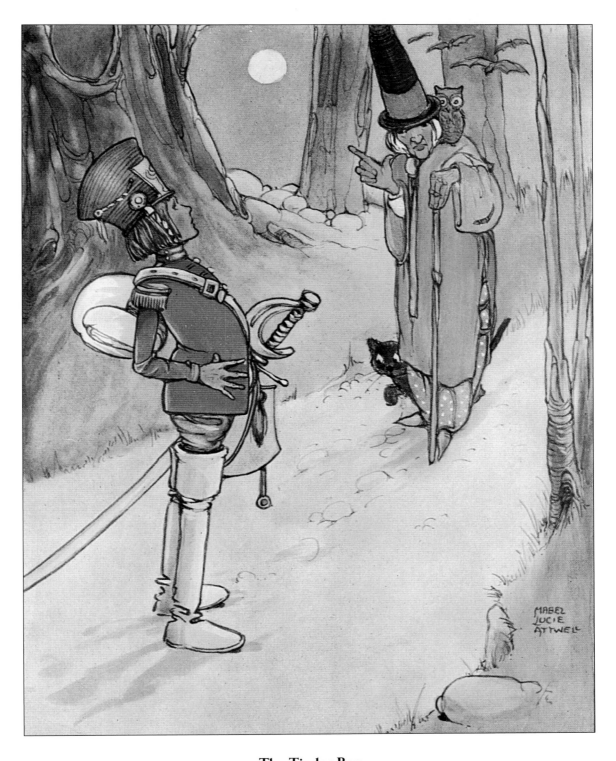

The Tinder-Box

"The Tinder-Box," *Hans Andersen's Fairy Tales*
MABEL LUCIE ATTWELL, 1914

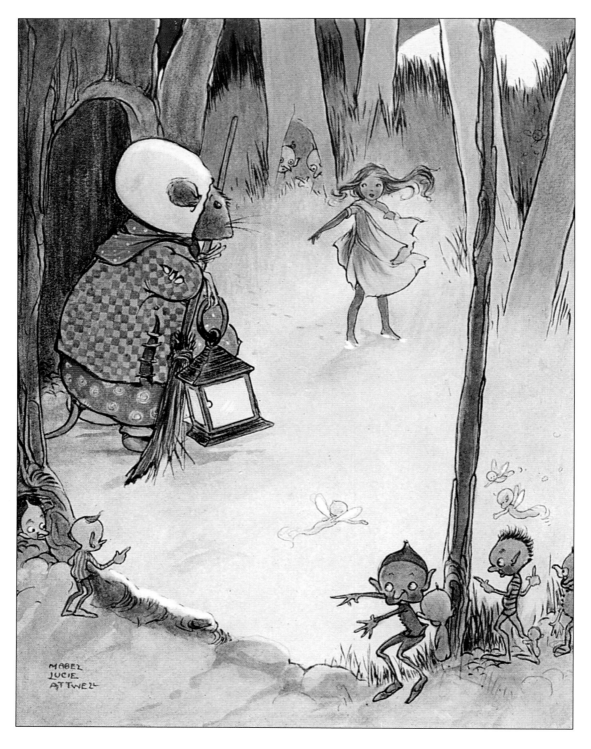

Thumbelina

"Thumbelina," Hans Andersen's Fairy Tales
MABEL LUCIE ATTWELL, 1914

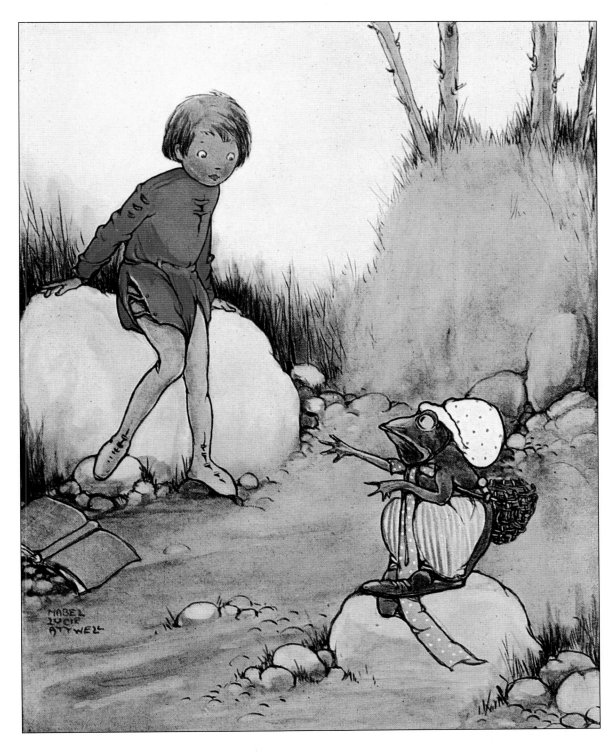

Little Tuk

"Little Tuk," *Hans Andersen's Fairy Tales*
MABEL LUCIE ATTWELL, 1914

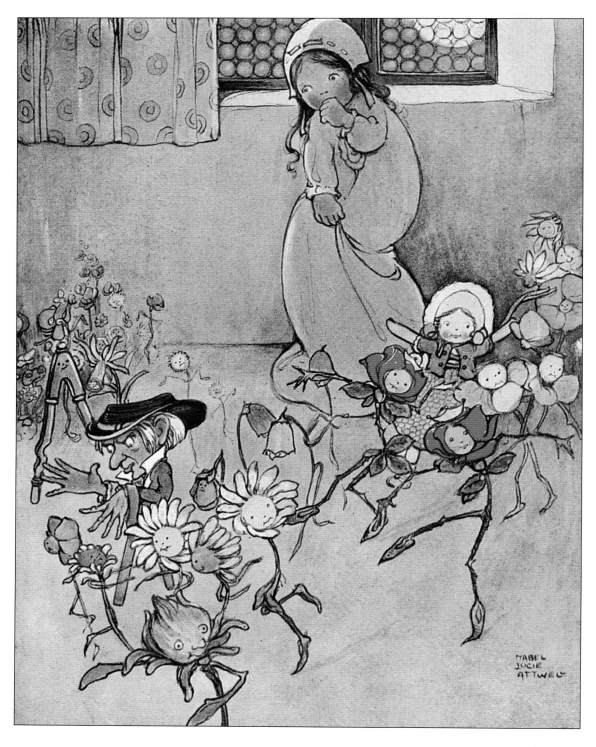

Little Ida's Flowers

"Little Ida's Flowers," *Hans Andersen's Fairy Tales*
MABEL LUCIE ATTWELL, 1914

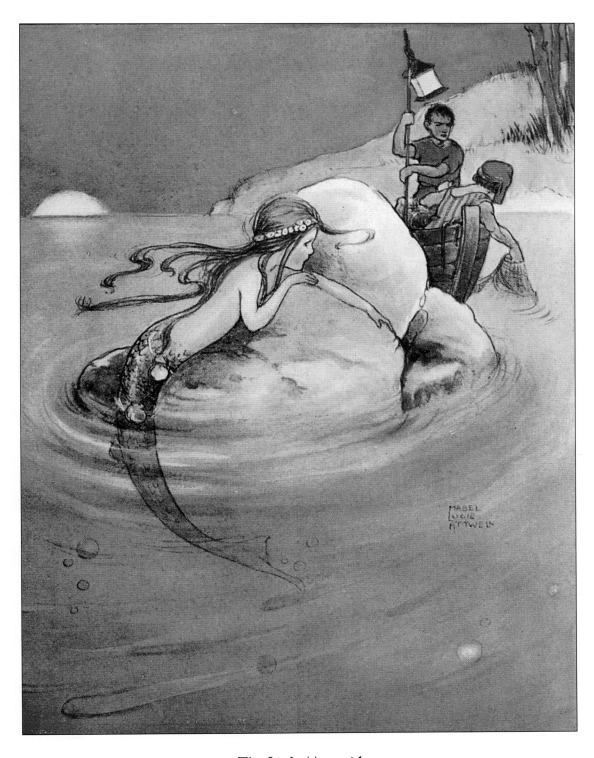

The Little Mermaid

"The Little Mermaid," *Hans Andersen's Fairy Tales*
MABEL LUCIE ATTWELL, 1914

Opposite:
**The Princess . . . could not speak a word.
At length, however, she got up and gave John her hand**

"The Travelling Companion," *Hans Andersen's Fairy Tales*
A. DUNCAN CARSE, 1912

A. Duncan Carse, 1876-1938
Hans Andersen's Fairy Tales, 1912

Little documentation exists for this British watercolorist, who often painted fairy tale subjects. This volume of Andersen illustrations is by far Carse's most enduring work, and generally is the most available.

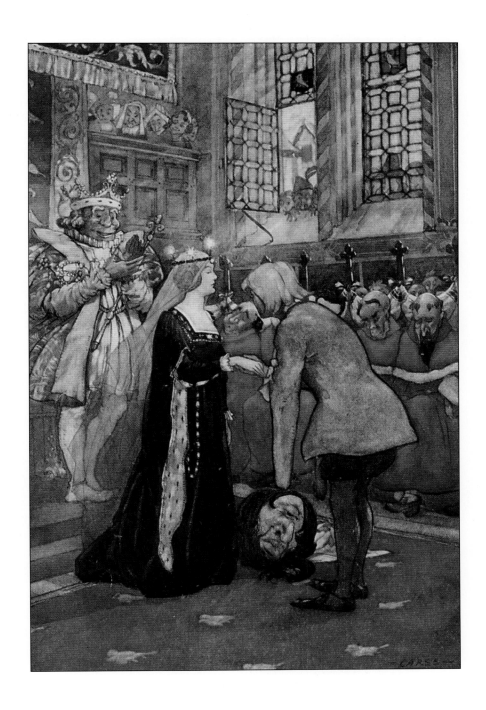

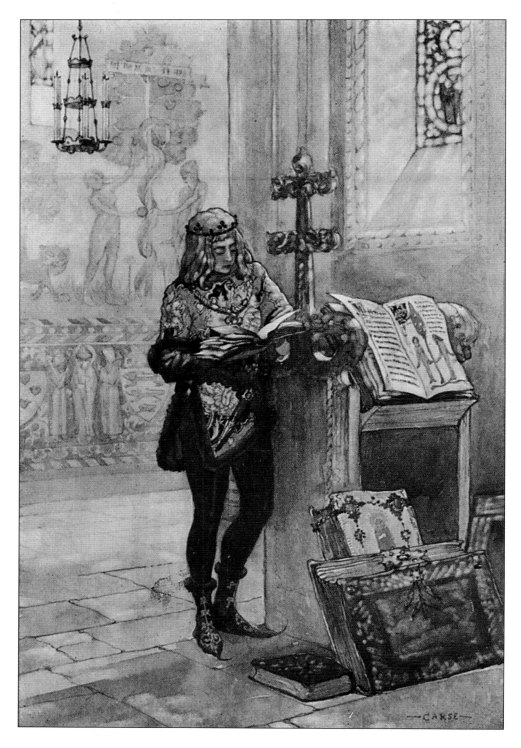

**Where the Garden of Paradise was to be found,
of that there was not a word in his books**

"The Garden of Paradise," *Hans Andersen's Fairy Tales*
A. Duncan Carse, 1912

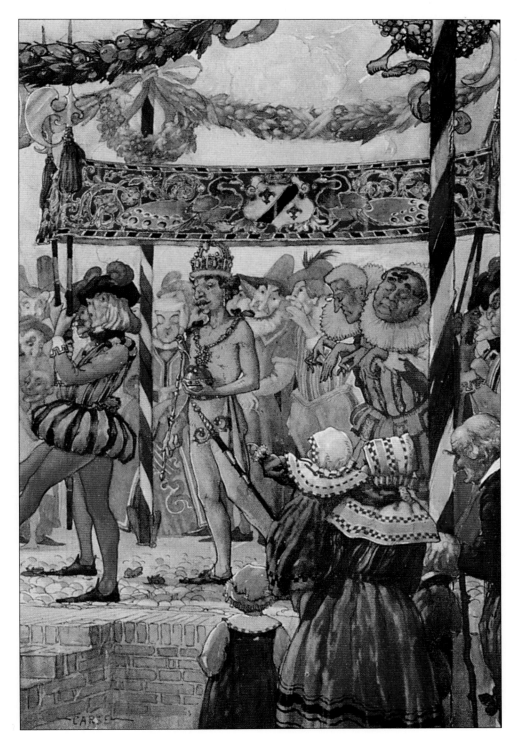

"But he has nothing on," said at length a little child

"The Emperor's New Clothes," Hans Andersen's Fairy Tales
A. DUNCAN CARSE, 1912

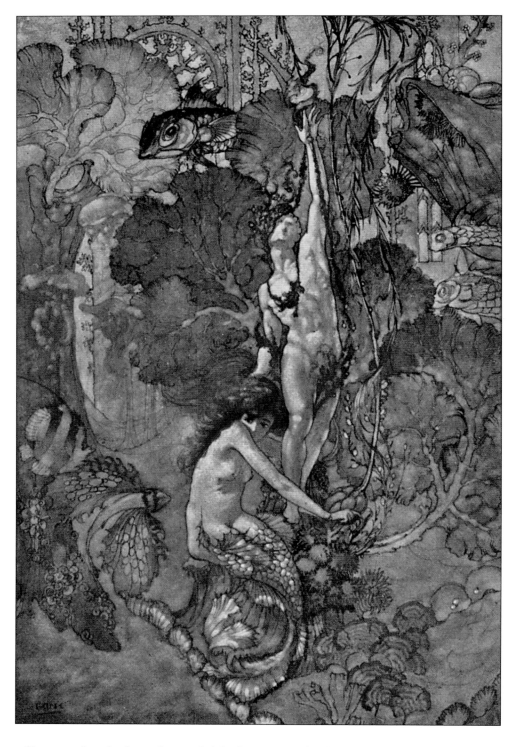

She cared only for a beautiful little statue of a boy, of pure white marble

"The Little Mermaid," *Hans Andersen's Fairy Tales*
A. DUNCAN CARSE, 1912

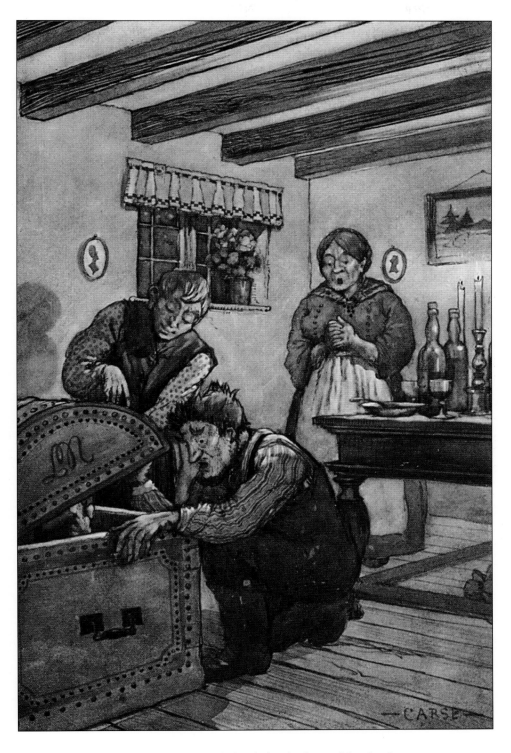

The farmer opened the lid a little and looked in

"Little Klaus and Big Klaus," *Hans Andersen's Fairy Tales*
A. DUNCAN CARSE, 1912

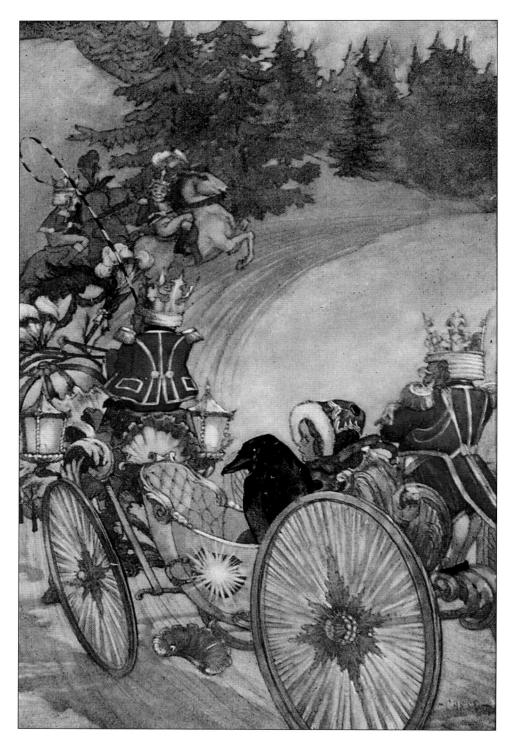

A new coach of pure gold drew up at the door

"The Snow Queen," *Hans Andersen's Fairy Tales*
A. DUNCAN CARSE, 1912

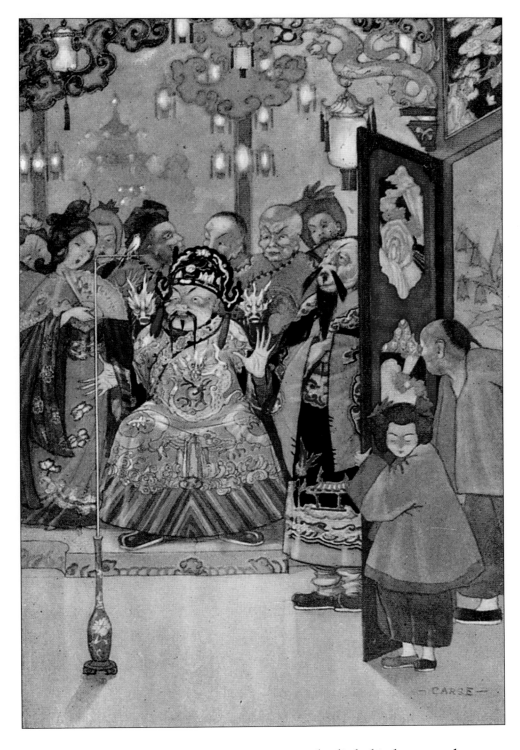

The whole Court was present even to the little kitchen wench

"The Nightingale," Hans Andersen's Fairy Tales
A. DUNCAN CARSE, 1912

Opposite: **Kay and the Snow Queen**

"The Snow Queen," *Fairy Tales from Hans Andersen*
HARRY CLARKE, 1916

Harry Clarke, 1889-1931
Fairy Tales from Hans Andersen, 1916

The Irish artist Harry Clarke got his start in design through his father, an accomplished stained-glass craftsman. Though the younger Clarke is more widely recognized today as an illustrator, it was stained-glass design that remained his forte; he focused most of his energies on it during his brief career. The illustrations that Clarke produced often are suggestive of stained glass, as they include large, flat expanses of color. Clarke's bookwork showcases his strong design sense, as well as a drawing style that is often compared to that of Aubrey Beardsley and Kay Neilsen. All three artists were greatly influenced by the commercial arts of the period. Between 1913 and 1928, Clarke completed work on six major books, of which Andersen's Tales was the first.

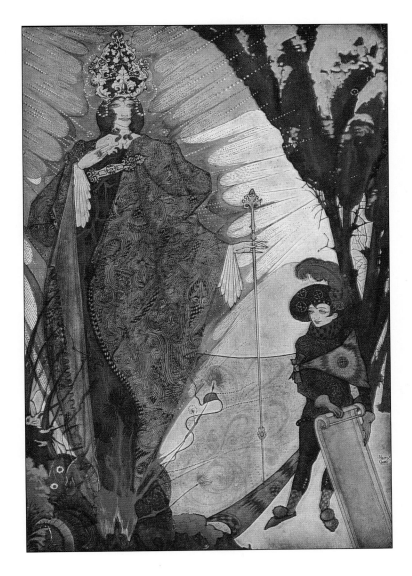

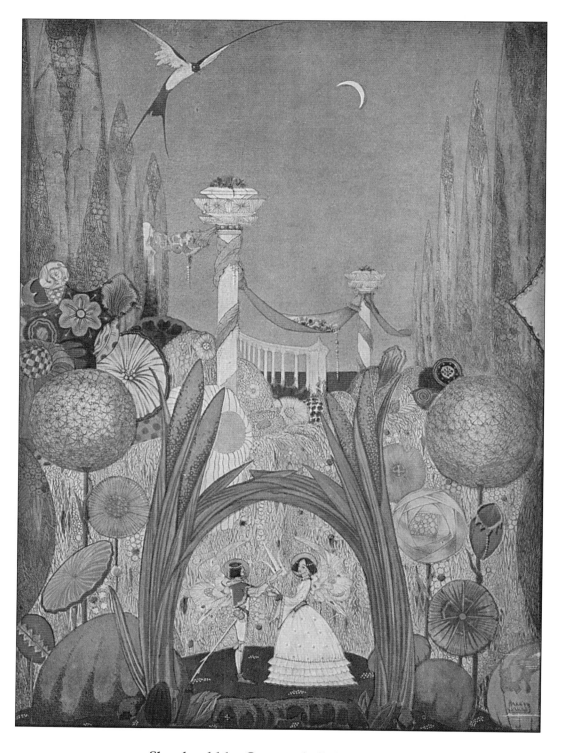

She should be Queen of all the Flowers

"Thumbelina," *Fairy Tales from Hans Andersen*
HARRY CLARKE, 1916

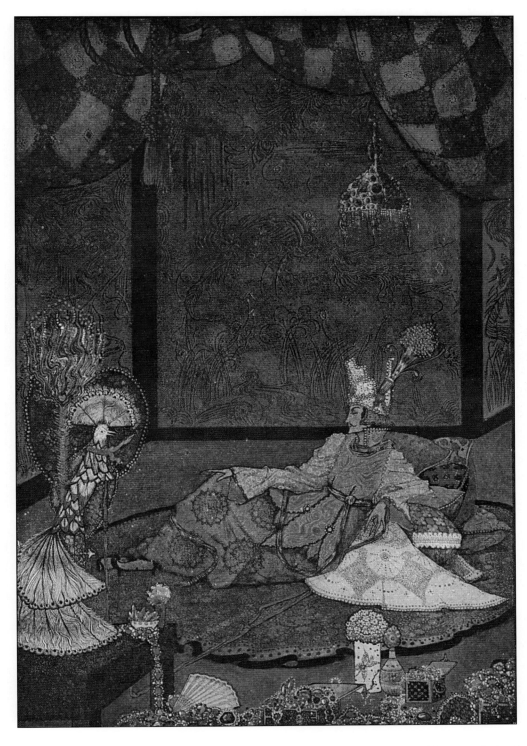

The Artificial Bird had its place on a silken cushion close to the Emperor's bed

"The Nightingale," Fairy Tales from Hans Andersen
HARRY CLARKE, 1916

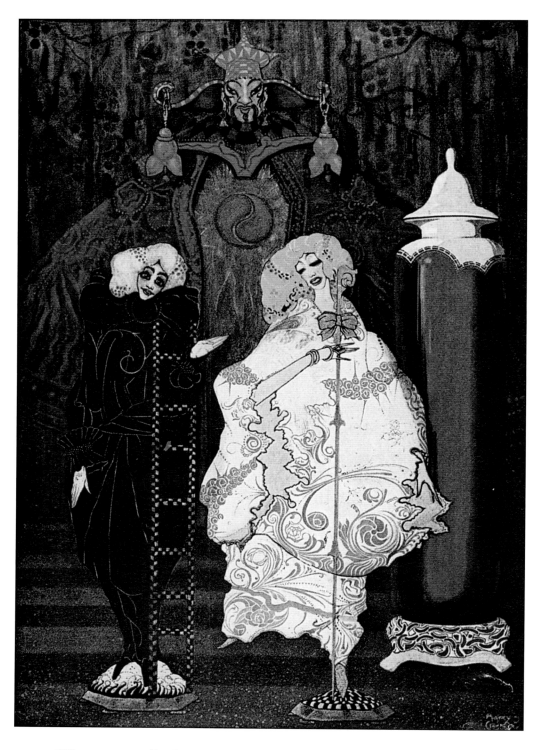

"Have you really the courage to go into the wide world with me?"

"The Shepherdess and the Chimney-sweeper," *Fairy Tales from Hans Andersen*
HARRY CLARKE, 1916

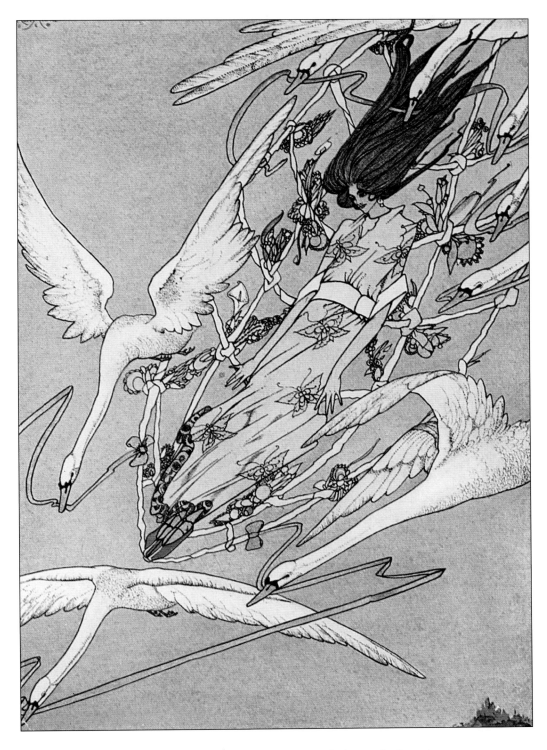

The whole day they flew onward through the air

"The Wild Swans," *Fairy Tales from Hans Andersen*
HARRY CLARKE, 1916

Opposite: **Headpiece**

"The Lambton Worm," *Fairy-Gold: A Book of Old English Fairy Tales*
HERBERT COLE, 1906

HERBERT COLE, 1867-1930
Fairy-Gold: A Book of Old English Fairy Tales, 1906

A prolific magazine illustrator who made the jump to illustrated books at the end of the nineteenth-century, Herbert Cole produced work for numerous titles that have become classics, such as the *Rubaiyat of Omar Khayyam, The Rime of the Ancient Mariner,* and *The Memoirs of Sherlock Holmes.* Most of Cole's subjects, however, were not children's fare; the 1906 edition of collected English tales is one of the few Cole titles to be sold as a children's book, although his work has a decidedly sophisticated look, not far from the pre-Raphaelite works of the period. Cole's method here is apply watercolor over pencil, while the numerous ink pieces reflected the influence of woodcut illustrations done a generation earlier. Cole produced illustrations until late in his life, working on new projects until 1926.

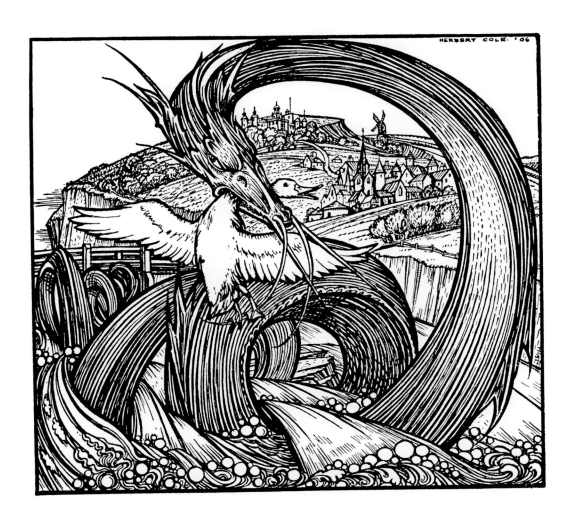

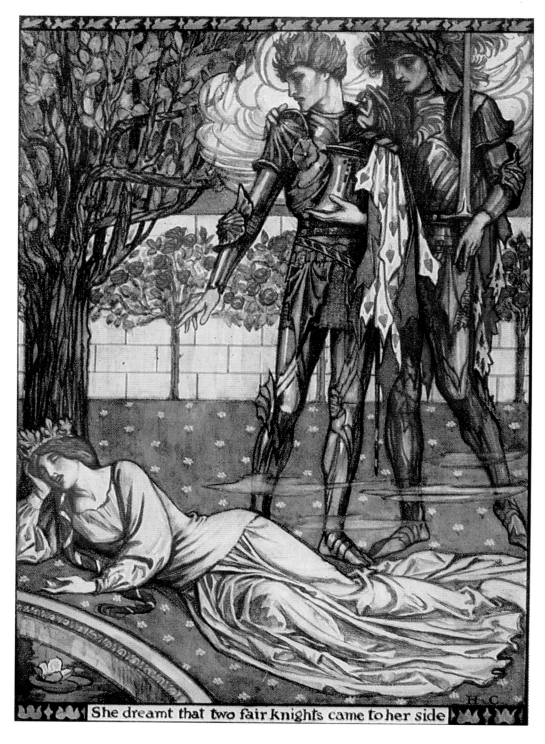

She dreamt that two fair knights came to her side

"The Imp Tree," *Fairy-Gold: A Book of Old English Fairy Tales*
HERBERT COLE, 1906

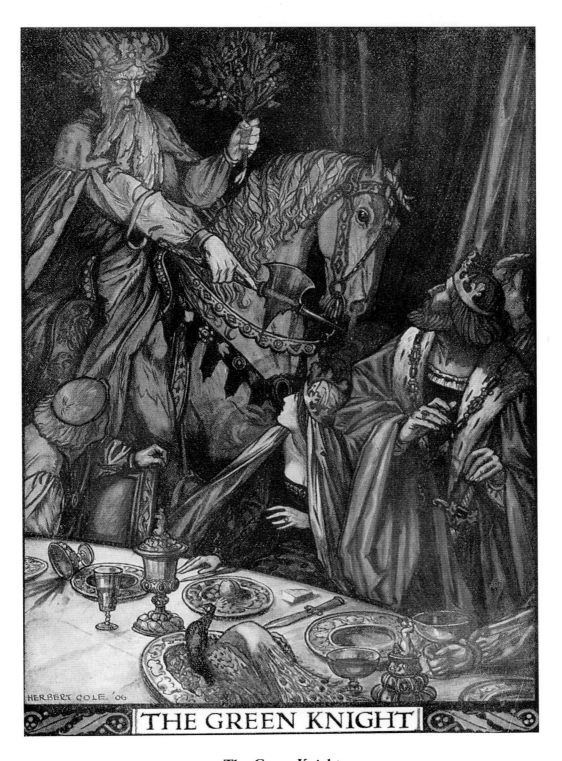

The Green Knight

"The Green Knight," *Fairy-Gold: A Book of Old English Fairy Tales*
HERBERT COLE, 1906

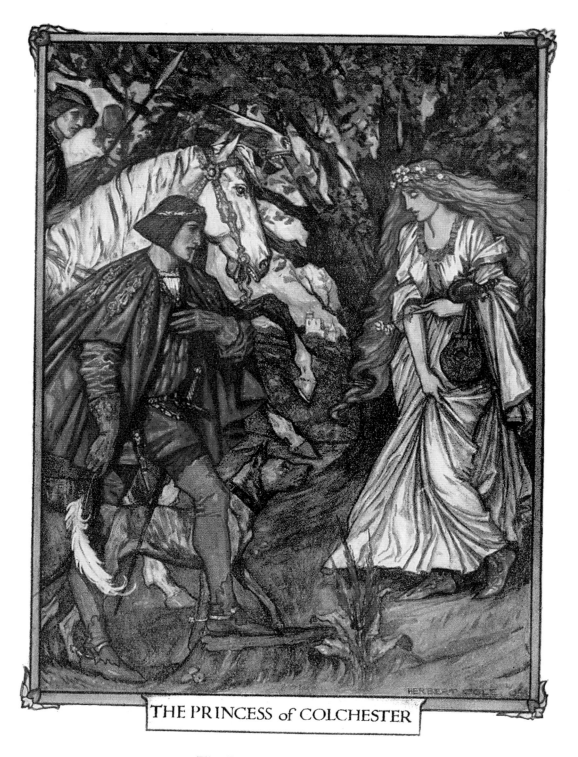

THE PRINCESS of COLCHESTER

The Princess of Colchester

"The Princess of Colchester," *Fairy-Gold: A Book of Old English Fairy Tales*
HERBERT COLE, 1906

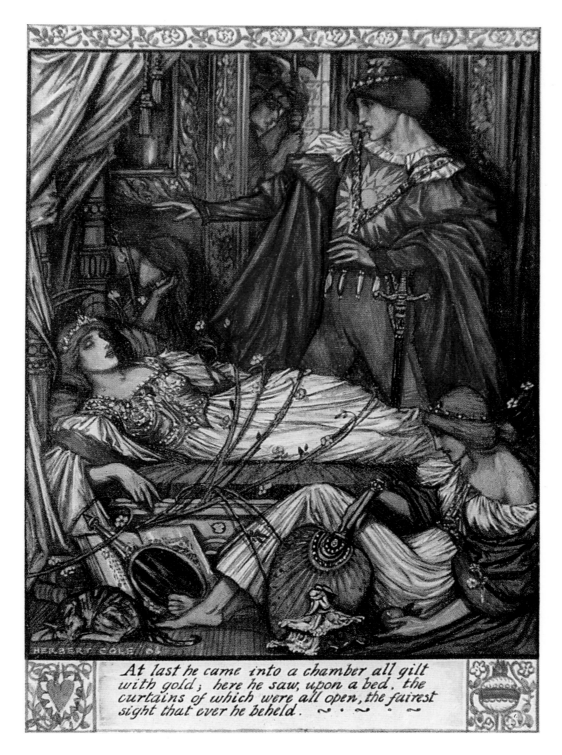

At last he came into a chamber all gilt
with gold; here he saw, upon a bed, the
curtains of which were all open, the fairest
sight that ever he beheld. ~ . ~ . .

**At last he came into a chamber / All gilt with gold, here he saw, upon a bed, the
curtains of which were all open, the fairest sight that ever he beheld**

"The Sleeping Beauty," *Fairy-Gold: A Book of Old English Fairy Tales*
HERBERT COLE, 1906

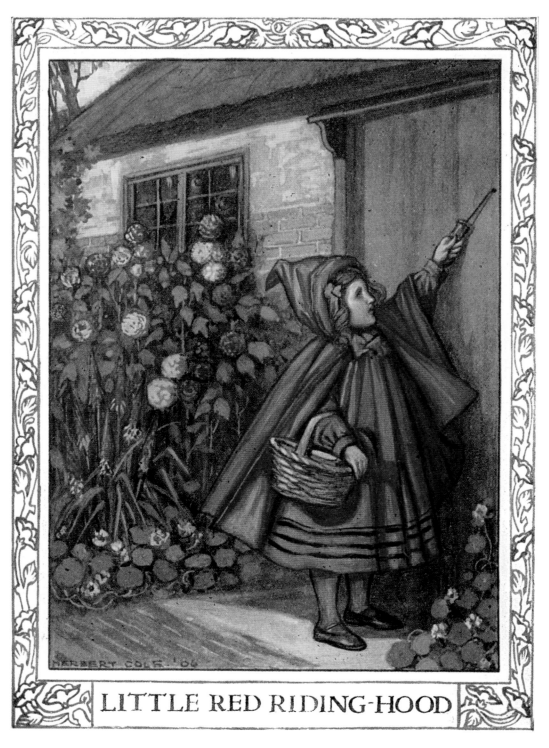

Little Red Riding-Hood

"Little Red Riding-Hood," *Fairy-Gold: A Book of Old English Fairy Tales*
HERBERT COLE, 1906

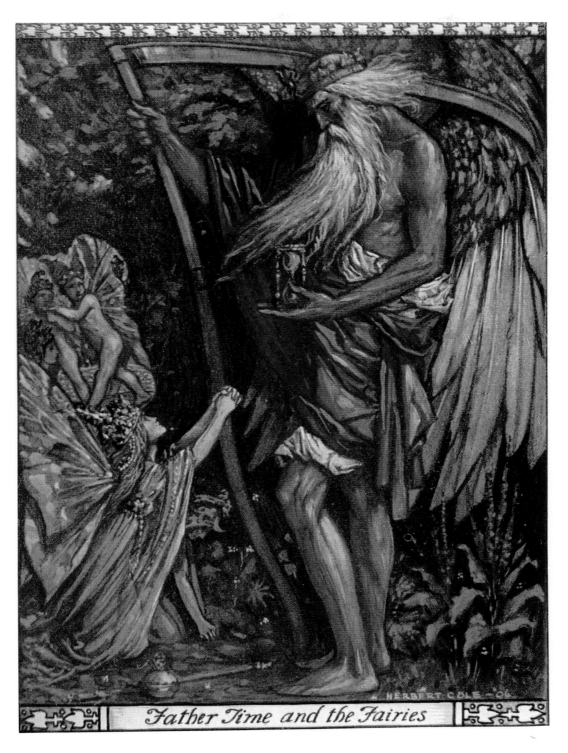

Father Time and the Fairies

Father Time and the Fairies

"The Defeat of Time," *Fairy-Gold: A Book of Old English Fairy Tales*
HERBERT COLE, 1906

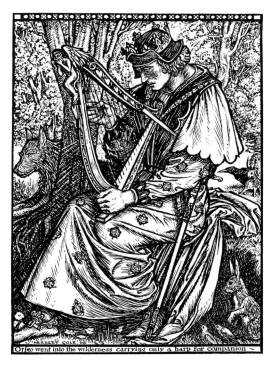

Orfeo went into the wilderness carrying only a harp for companion

"The Imp Tree"

In two months but a day, the King Has brought his new Queen home

"The Laidley Worm of Spindleston"

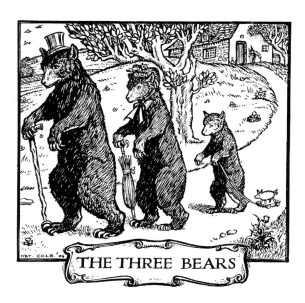

The Three Bears

"The Three Bears,"
Fairy-Gold: A Book of Old English Fairy Tales
HERBERT COLE, 1906

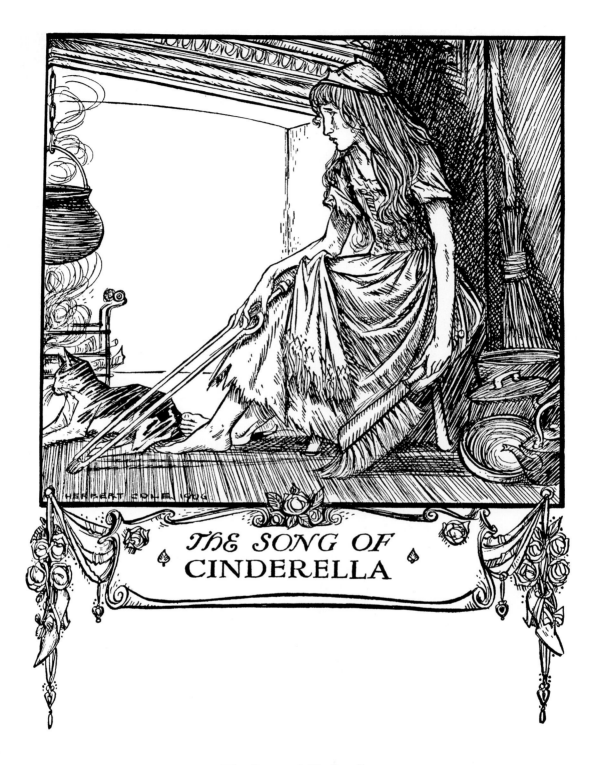

The Song of Cinderella

"Cinderella, or The Little Glass Slipper," *Fairy-Gold: A Book of Old English Fairy Tales*
HERBERT COLE, 1906

Margery's new Pair of Shoes

"Goody Two-Shoes," *Goody Two Shoes' Picture Book*
WALTER CRANE, 1901

Walter Crane, 1845-1915
Household Stories by the Brothers Grimm, 1882
Goody Two Shoes' Picture Book, 1901

Walter Crane's career in illustration and book design was at its peak just previous to the Golden Age of book illustration, but he was one of its most influential practitioners, and his work had a lasting impact for generations to come. Crane would return again and again to fairy tales and myths as subject matter, and his repeated successes made him one of book illustration's first real "stars"—his name became a selling point for the books he had worked on. Crane absorbed many influences in forming his style, among them Medieval and Renaissance works for their symbolism, and Japanese printing for its distinctive use of line and color.

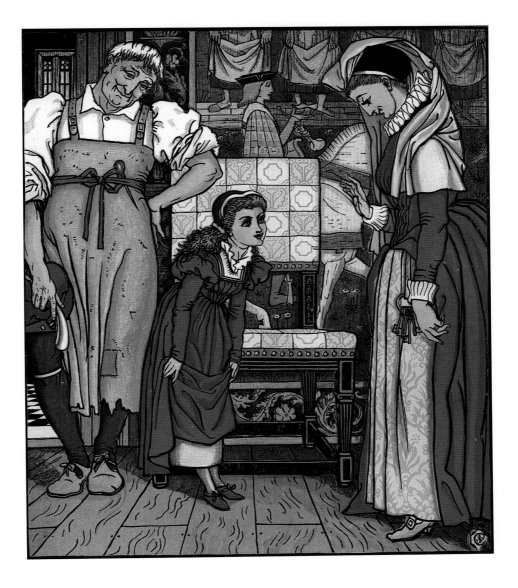

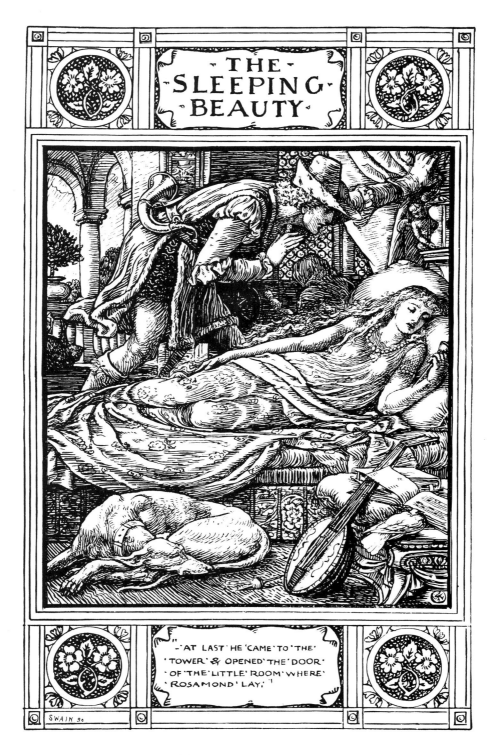

The Sleeping Beauty

"The Sleeping Beauty," *Household Stories by the Brothers Grimm*
WALTER CRANE, 1882

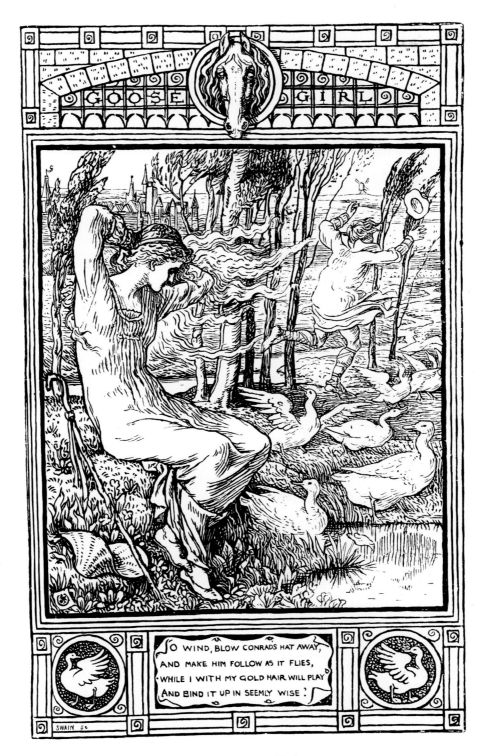

GOOSE GIRL

O WIND, BLOW CONRADS HAT AWAY,
AND MAKE HIM FOLLOW AS IT FLIES,
WHILE I WITH MY GOLD HAIR WILL PLAY
AND BIND IT UP IN SEEMLY WISE.

SWAIN sc

The Goose Girl

"The Goose Girl," Household Stories by the Brothers Grimm
WALTER CRANE, 1882

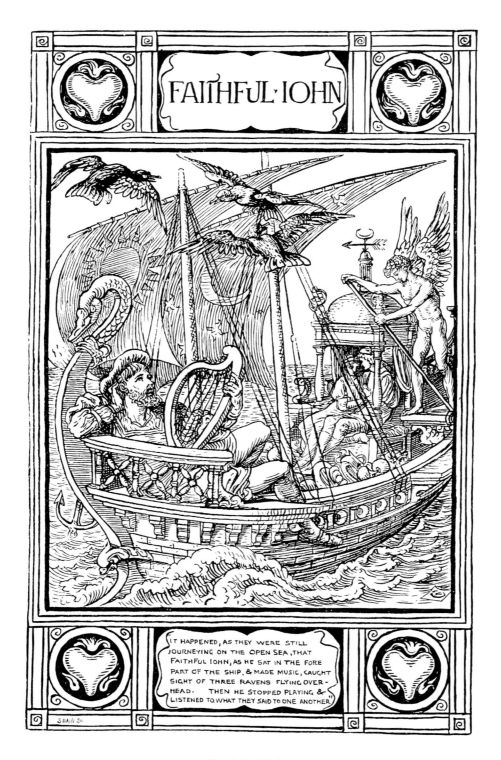

Faithful John

"Faithful John," Household Stories by the Brothers Grimm
WALTER CRANE, 1882

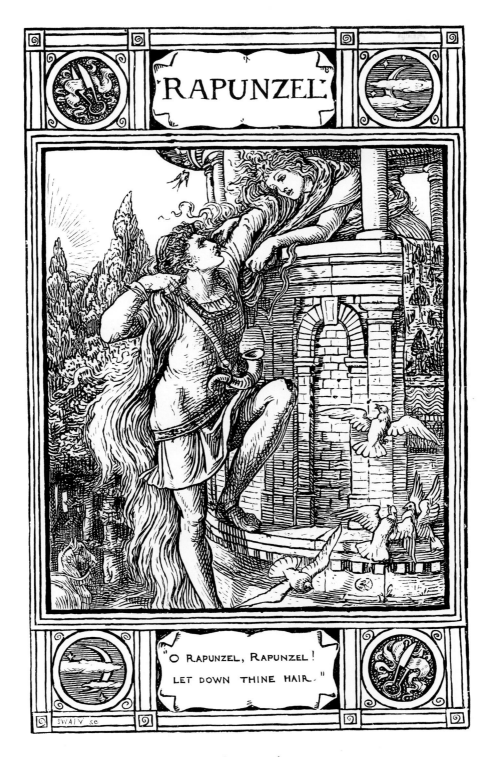

Rapunzel

"Rapunzel," *Household Stories by the Brothers Grimm*
WALTER CRANE, 1882

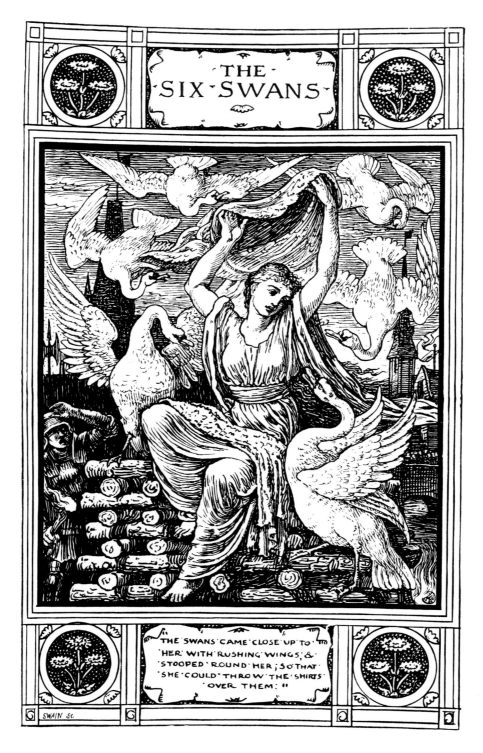

The Six Swans

"The Six Swans," Household Stories by the Brothers Grimm
WALTER CRANE, 1882

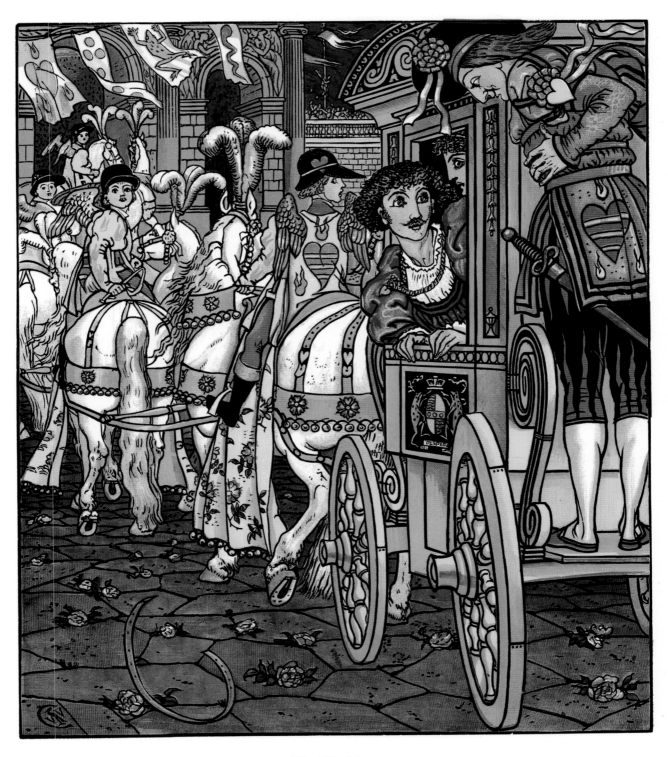

The Wedding

"The Frog Prince," *Goody Two Shoes' Picture Book*
WALTER CRANE, 1901

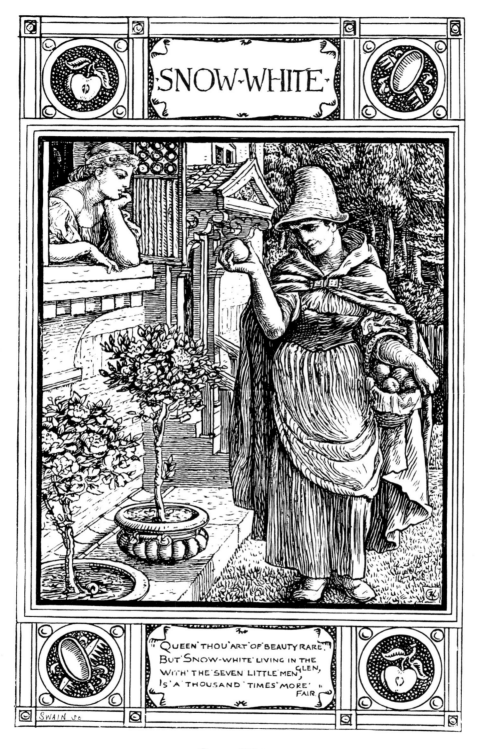

Snow-White

"Snow-White," Household Stories by the Brothers Grimm
WALTER CRANE, 1882

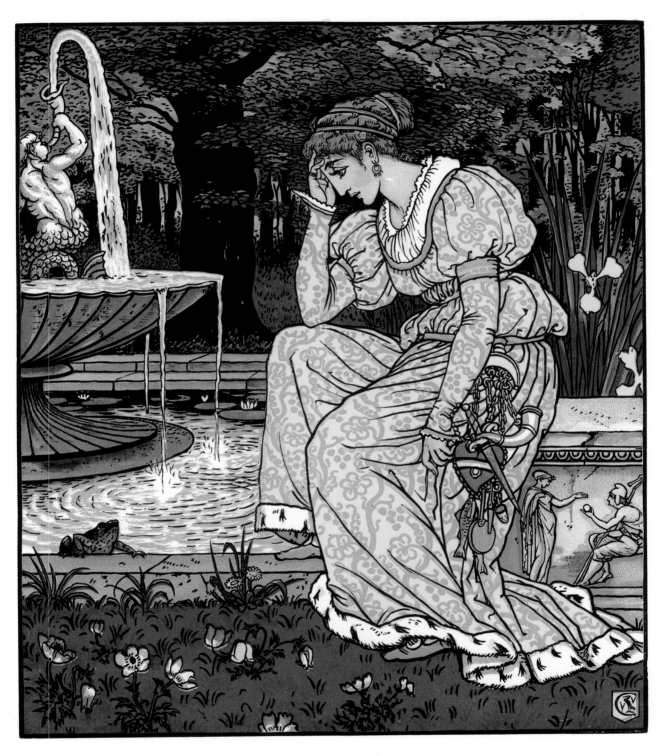

The Princess At the Fountain

"The Frog Prince," *Goody Two Shoes' Picture Book*
WALTER CRANE, 1901

One after another he dragged them from under the bed

"Little Tom Thumb," *Les Contes de Perrault*
Gustave Doré, 1867

Gustave Doré, 1832-1883
Les Contes de Perrault [Perrault's Fairy Tales], 1867

The French artist Paul Gustave Doré created imagery for all sorts of tales—historical, romantic, satirical, religious, and, on at least one occasion, a collection of fairy tales. In 1867 he produced a set of drawings for the tales of Perrault, exhibiting the elements that he had become known for: expressive figures, atmospheric space, and a masterful understanding of light and shadow. During the mid-nineteenth century, Doré helped determine the direction that illustrated books would take. His extraordinary imagery helped to create a market for high-quality illustrated books; in the future, these "gift-books" would collect the best illustrations and writing to provide entertainment to wide audiences.

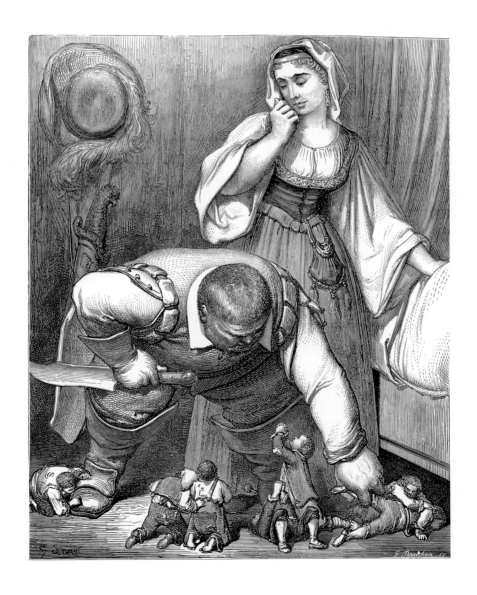

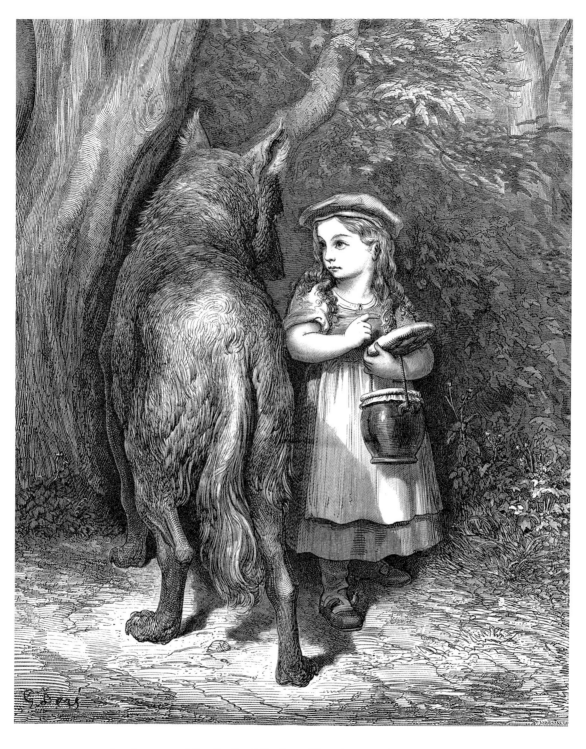

In the wood Little Red Riding Hood met old Father Wolf

"Little Red Riding Hood," Les Contes de Perrault
GUSTAVE DORÉ, 1867

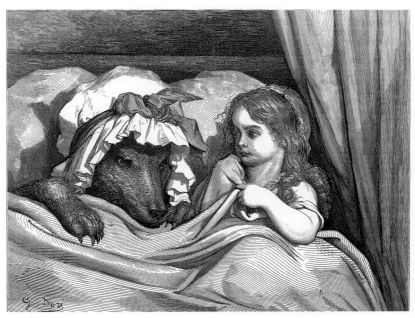

She was astonished to see how her grandmother looked

"Little Red Riding Hood," *Les Contes de Perrault*
GUSTAVE DORÉ, 1867

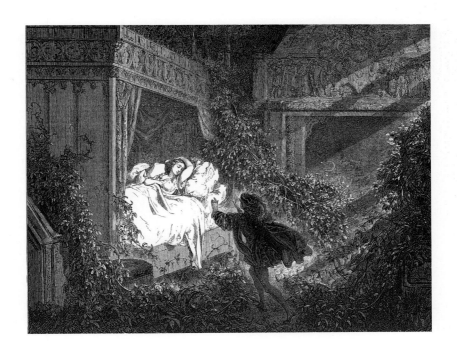

Reclining upon a bed was a princess of radiant beauty

"The Sleeping Beauty in the Wood," *Les Contes de Perrault*
GUSTAVE DORÉ, 1867

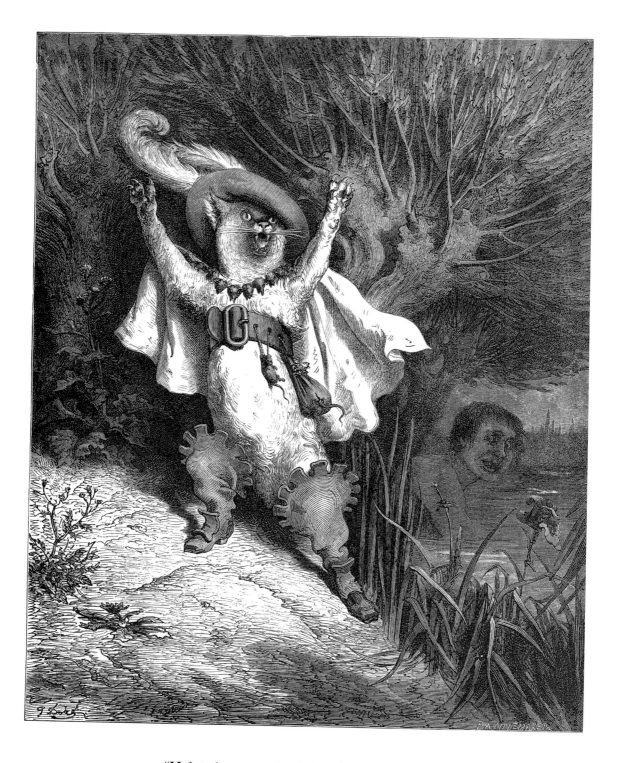

"Help! the marquis of Carabas is drowning!"

"The Master Cat or Puss in Boots," *Les Contes de Perrault*
GUSTAVE DORÉ, 1867

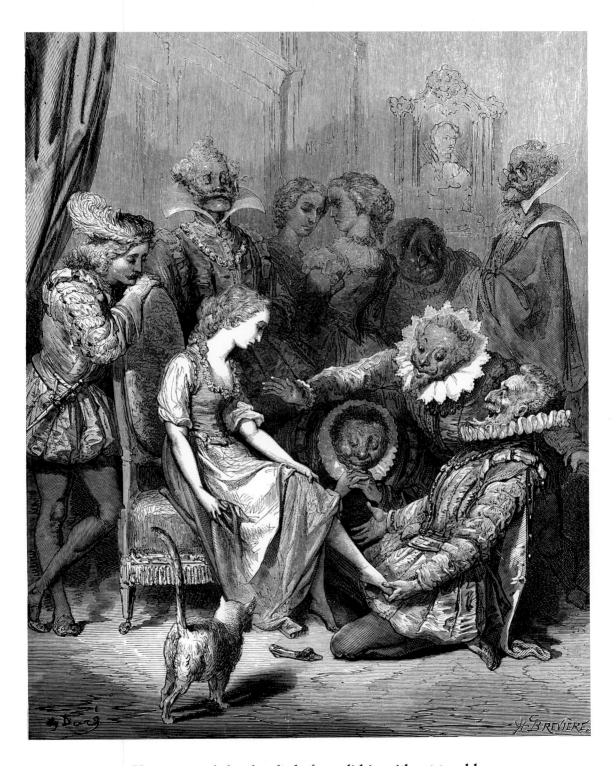

He perceived that her little foot slid in without trouble

"Cinderella, or The Little Glass Slipper," *Les Contes de Perrault*
GUSTAVE DORÉ, 1867

She used to creep away to the chimney-corner and seat herself among the cinders

"Cinderella," *The Sleeping Beauty and Other Fairy Tales*
EDMUND DULAC, 1910

Edmund Dulac, 1882-1953

The Sleeping Beauty and Other Fairy Tales, 1910
Stories from Hans Andersen, 1911

Edmund Dulac was among the elite children's book illustrators of his day, when the gift-book was at its height of popularity. From 1907 to 1918, the French artist produced scores of images for ten books, whose content ranged from fairy tales to poems by Poe to tales from the *Arabian Nights.* Greatly influenced by the prints and drawings that he had enjoyed in his youth, Dulac had high regard for imagery from Eastern tales and subjects. Later in his career, these stories became a specialty of the "star illustrator" at London's Hodder and Stoughton publishing house. The work that Edmund Dulac produced for Hans Christian Andersen's fairy tales is widely considered to be his best—these images are well loved not only for their artistry, but also because, a century later, the tales are still meaningful to today's audiences.

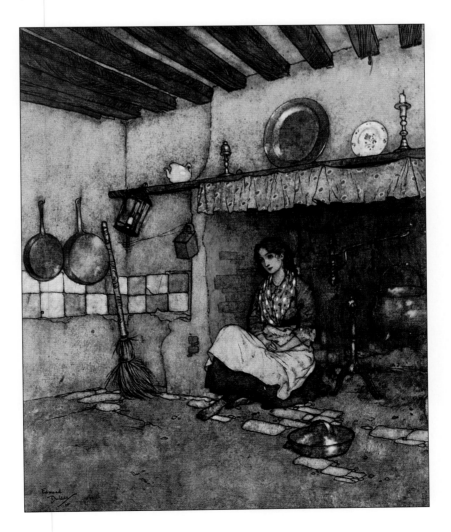

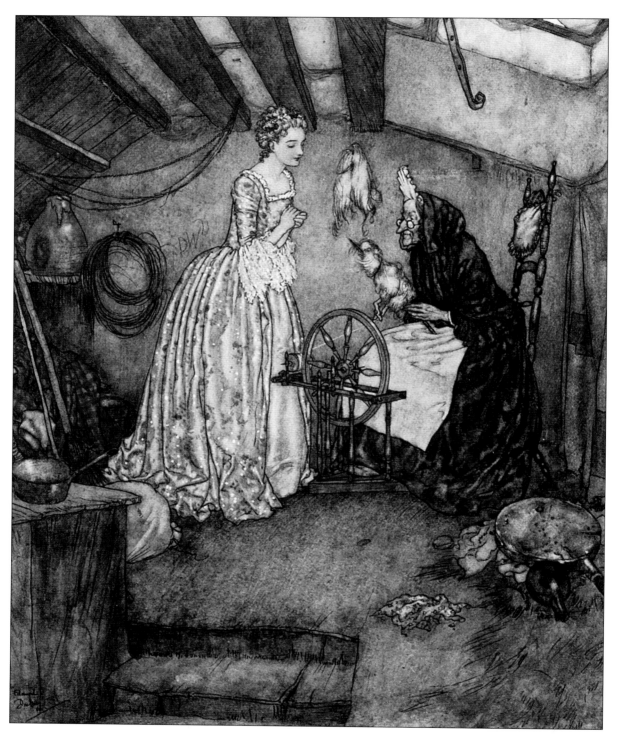

**"I am spinning, pretty one," answered the old woman,
who did not know who she was**

"Sleeping Beauty," *The Sleeping Beauty and Other Fairy Tales*
EDMUND DULAC, 1910

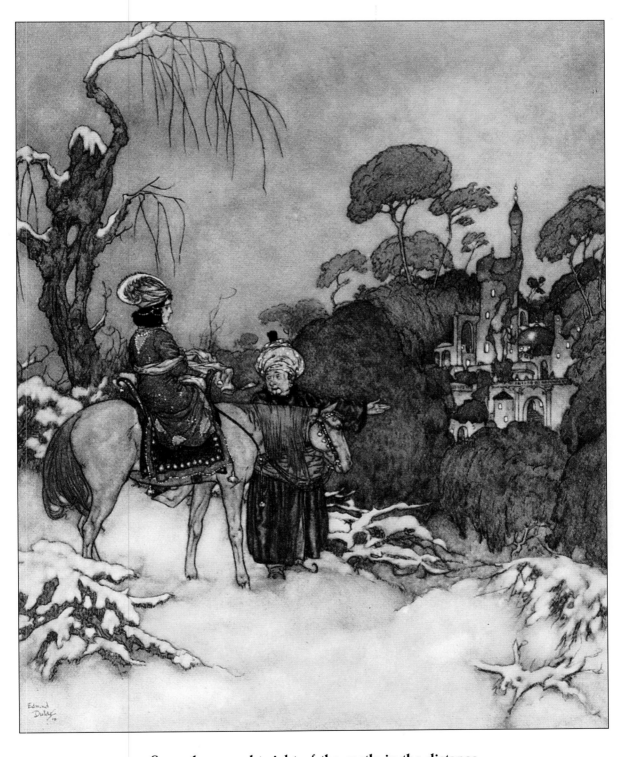

Soon they caught sight of the castle in the distance

"Beauty and the Beast," *The Sleeping Beauty and Other Fairy Tales*
EDMUND DULAC, 1910

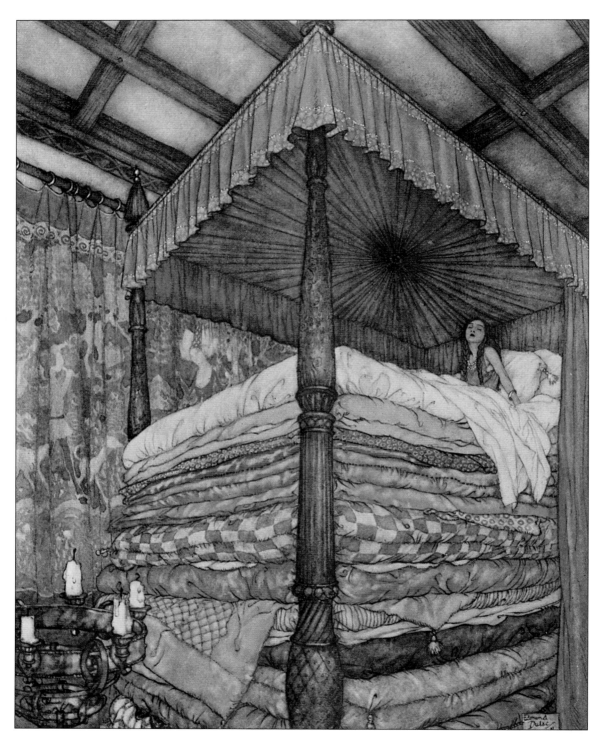

"I have hardly closed my eyes the whole night! Heaven knows what was in the bed. I seemed to be lying upon some hard thing, and my whole body is black and blue this morning. It is terrible!"

"The Real Princess," *Stories from Hans Andersen*
EDMUND DULAC, 1911

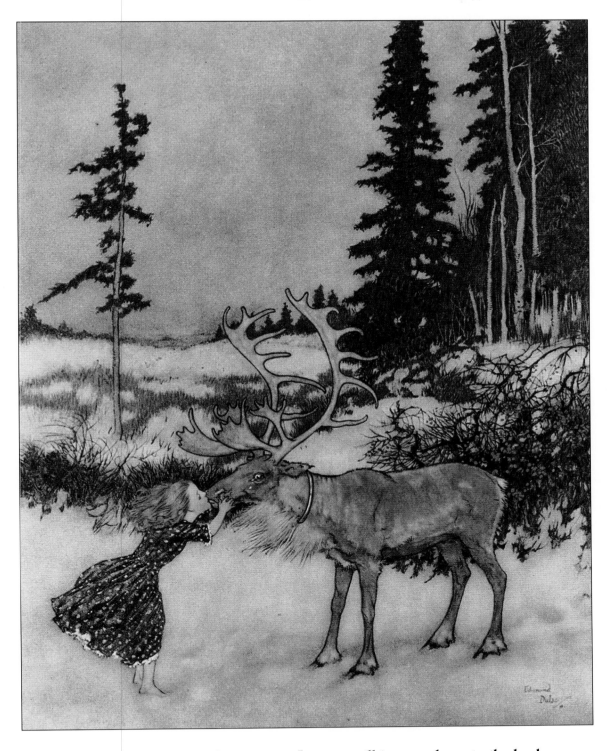

The reindeer did not dare to stop. It ran on till it came down to the bush with the red berries. There it put Gerda down, and kissed her on the mouth, while big shining tears trickled down its face

"The Snow Queen," *Stories from Hans Andersen*
EDMUND DULAC, 1911

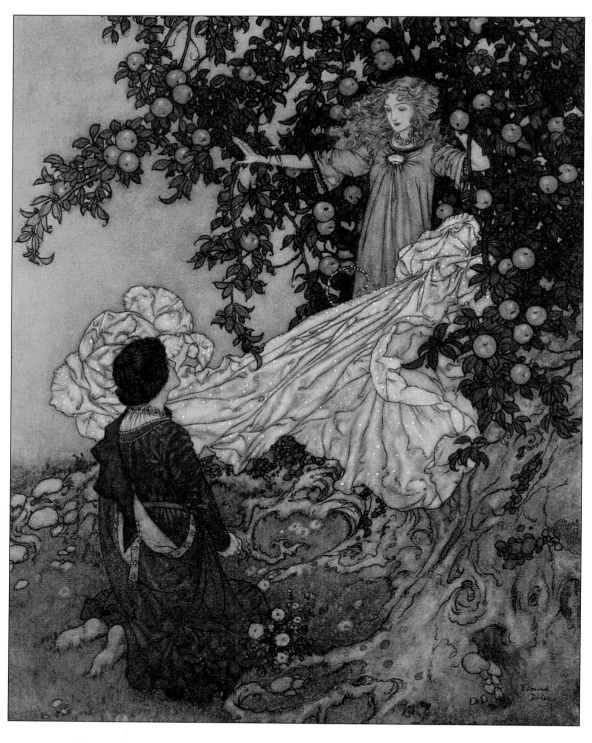

**The fairy dropped her shimmering garment, drew back the branches,
and a moment after was hidden within their depths**

"The Garden of Paradise," Stories from Hans Andersen
Edmund Dulac, 1911

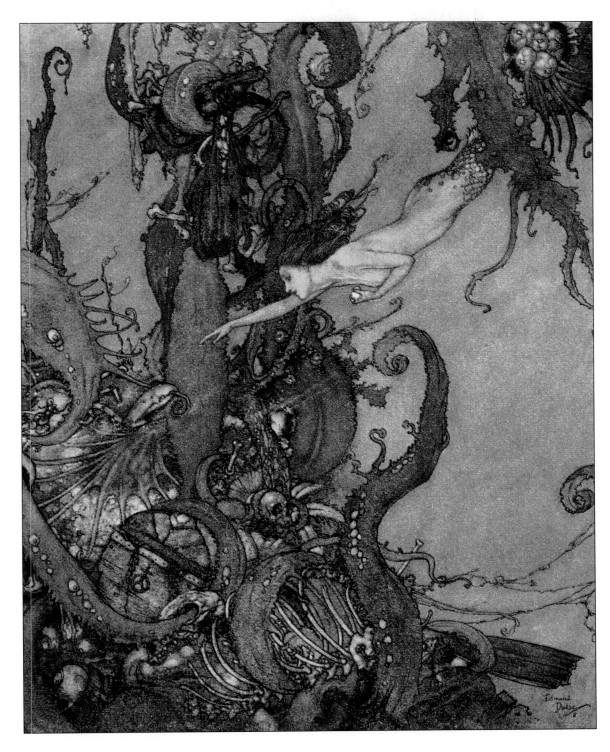

But the little mermaid had no need to do this, for at the mere sight of the bright liquid which sparkled in her hand like a shining star, they drew back in terror

"The Mermaid," Stories from Hans Andersen
EDMUND DULAC, 1911

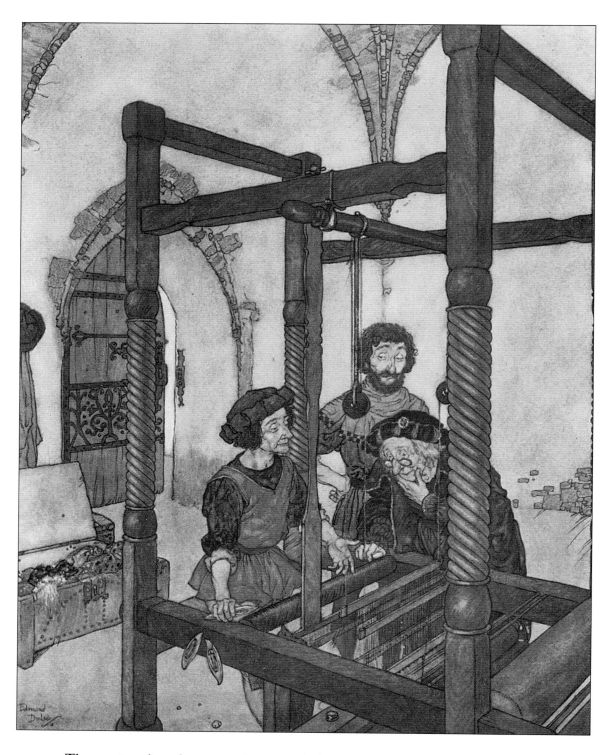

They pointed to the empty loom, and the poor old minister stared as hard as he could, but he could not see anything, for of course there was nothing to see

"The Emperor's New Clothes," *Stories from Hans Andersen*
EDMUND DULAC, 1911

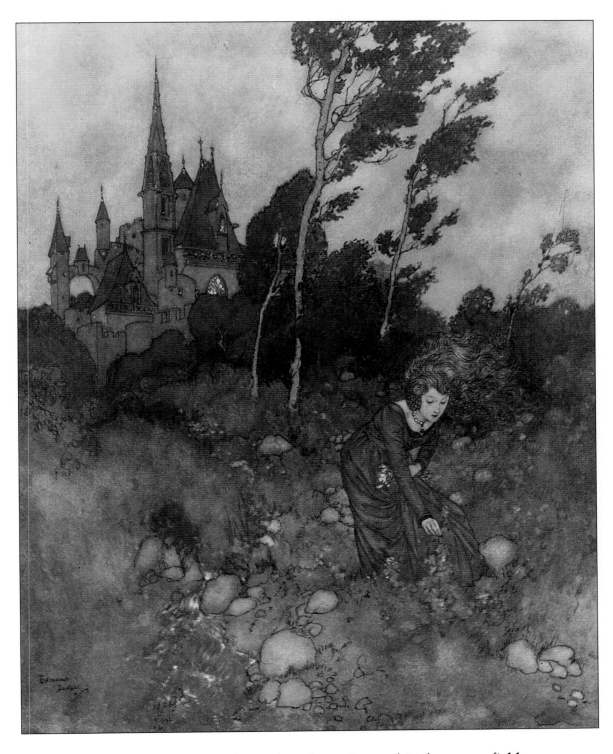

**I used to meet her in the garden, the ravine, and in the manor fields.
She was always picking flowers and herbs, those she knew her father
could use for healing drinks and potions**

"The Wind's Tale," *Stories from Hans Andersen*
EDMUND DULAC, 1911

The dwarfs cried out with wonder and astonishment, and brought their lamps to look at her and said, "Good heavens! What a lovely child she is"

"Snowdrop," Grimm's Fairy Tales
CHARLES FOLKARD, 1911

CHARLES FOLKARD, 1878-1963
Grimm's Fairy Tales, 1911

The long and prolific career of British cartoonist and illustrator Charles Folkard outlasted that of many of his contemporaries. Folkard focused his work on imagery for a young—or young-at-heart—audience, and his success was two-fold. With his creation of Teddy Tail, he became the first daily "cartoon strip" artist in England, and his illustration work for children's books was a steady part of his output throughout his career. Folkard's first multi-plate gift-book was *The Swiss Family Robinson* (1910), followed in 1911 by a definitive treatment of *Pinocchio*. With his edition of *Grimm's Fairy Tales*, Folkard became a "house illustrator" for the publisher A & C Black; he produced gift-books for Black for the next twenty years. Like his work for *Pinocchio*, this selection of images gained a long life through many reprints and can still be found in print nearly a century later.

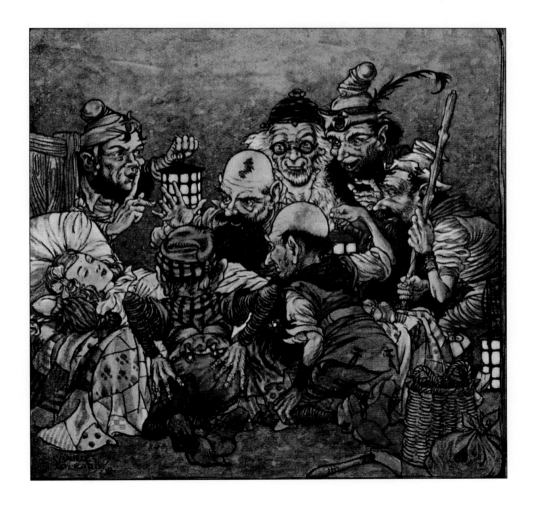

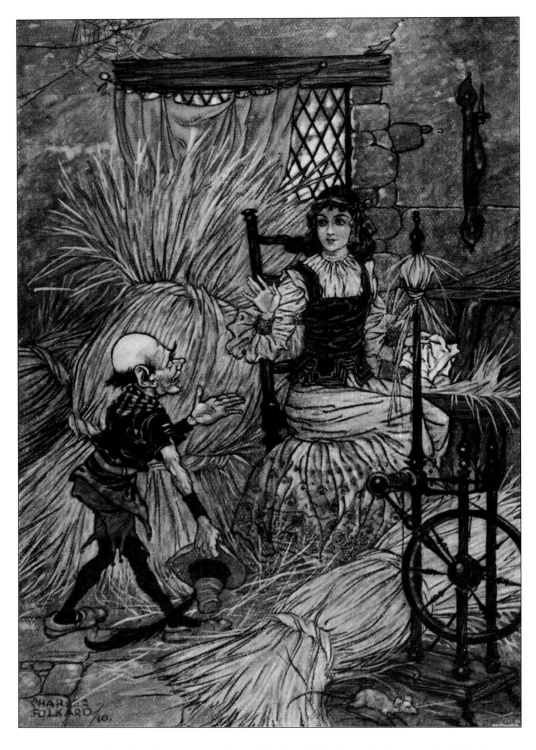

On a sudden the door opened, and a droll-looking little man hobbled in

"Rumpelstiltskin," *Grimm's Fairy Tales*
CHARLES FOLKARD, 1911

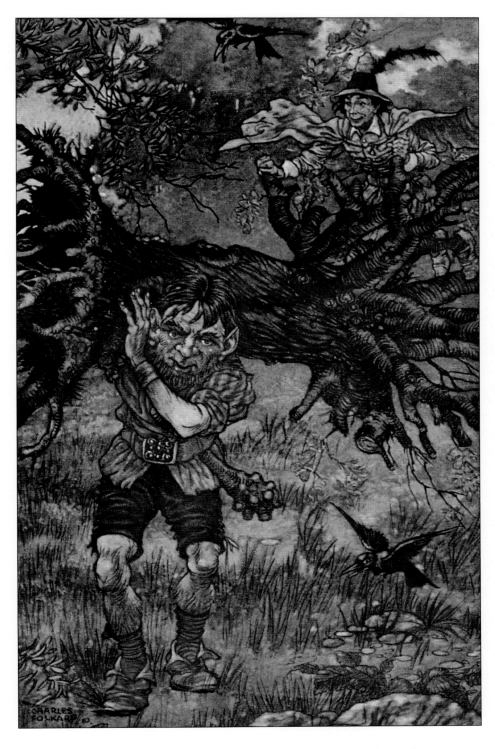

**The Giant took the trunk on his shoulder, but the tailor
seated himself on a branch**

"The Brave Little Tailor," *Grimm's Fairy Tales*
CHARLES FOLKARD, 1911

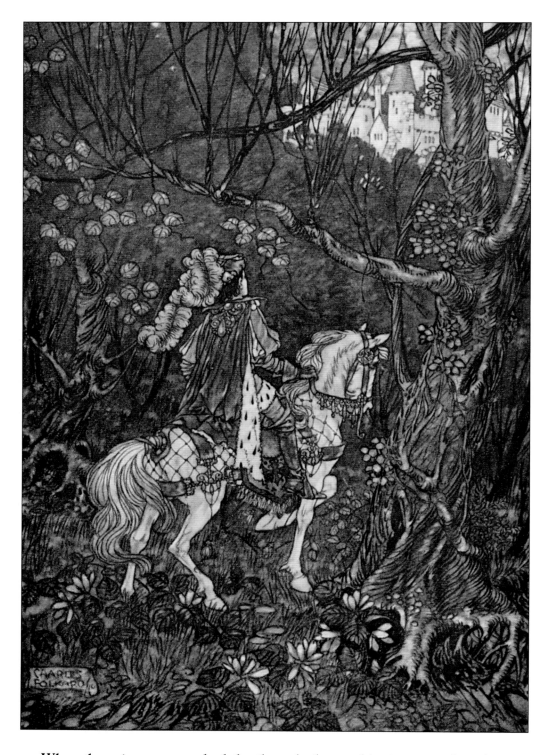

**When the prince approached the thorn hedge, to him it was nothing but
beautiful flowers which offered no resistance to his progress**

"The Sleeping Beauty," Grimm's Fairy Tales
CHARLES FOLKARD, 1911

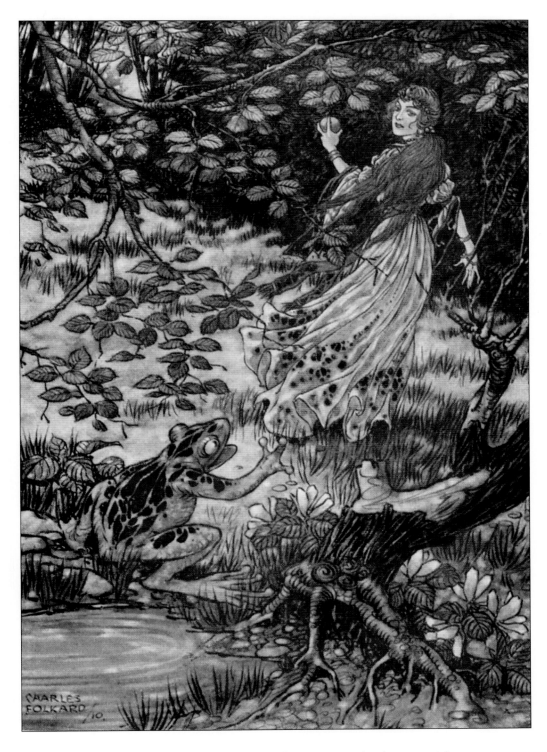

**The Frog called after her, "Stay, Princess, and take me with you,
as you promised," but she did not stop to hear a word**

"The Frog Prince," *Grimm's Fairy Tales*
CHARLES FOLKARD, 1911

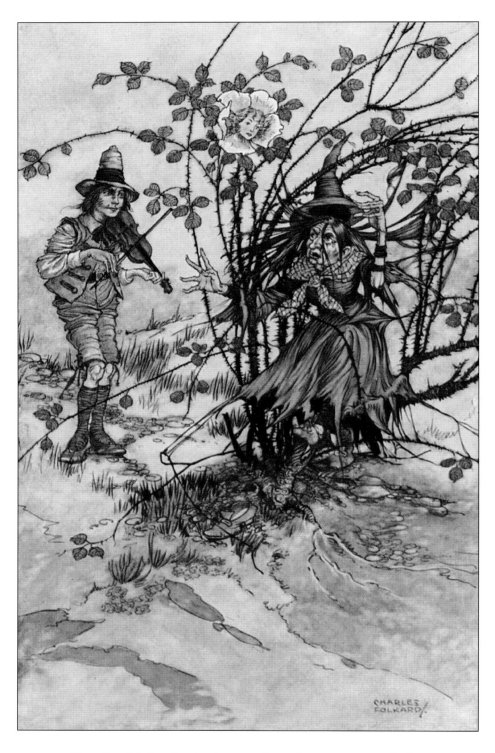

**But the fiddler beginning to play, she was compelled
to dance whether she would or not**

"Roland and his Bride," Grimm's Fairy Tales
CHARLES FOLKARD, 1911

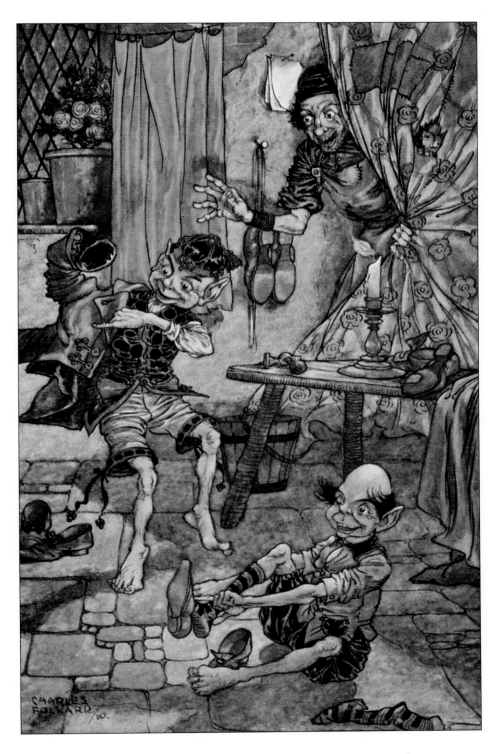

**About midnight they came in, and were going to sit down
to their work as usual; but when they saw the clothes lying for them
they laughed and were greatly delighted**

"The Elves and the Shoemaker," *Grimm's Fairy Tales*
CHARLES FOLKARD, 1911

The Sudden departure of Una's Parents

"Una and the Lion," *The Red Romance Book*
H. J. FORD, 1905

Harold J. Ford, 1860-1941

The Green Fairy Book, 1892
The Crimson Fairy Book, 1903
The Book of Romance, 1903
The Brown Fairy Book, 1904
The Red Romance Book, 1905

By the end of the Victorian era, before the idea of a color-plate book became a practical reality, H. J. Ford was turning out scores of beautiful line-art pieces for children's books. He later produced color work as well, but he is largely remembered today for his skilful use of pen and ink. If there is any common ground among Pre-Raphaelite and Victorian painters in England and book illustrators, H. J. Ford provides that bridge. The painter Edward Burne-Jones was among Ford's closest friends, and Ford was known to share many of the Pre-Raphaelite methods (the use of intense, jewel-like colors and abundant detail). Above all else, Ford was sensationally prolific during the prime period of his career—the late 1880s until World War I. A long partnership with prominent folk and fairy tale historian Andrew Lang kept Ford productive for the better part of two decades, yielding over eighteen collaborative titles between the two; later on, Ford worked on collections arranged by Lang's widow.

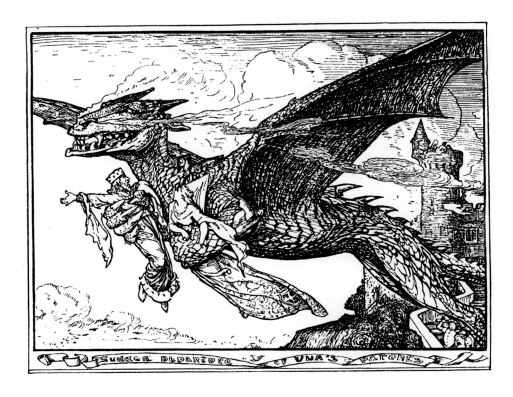

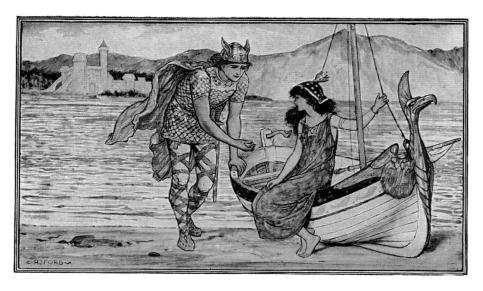

Sigurd meets Helga by the Lake and gives her a Ring

"The Horse Gullfaxi and the Sword Gunnföder," *The Crimson Fairy Book*
H. J. FORD, 1903

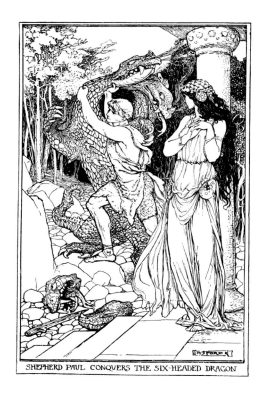

**Shepherd Paul conquers the
six-headed dragon**

"Shepherd Paul," *The Crimson Fairy Book*
H. J. FORD, 1903

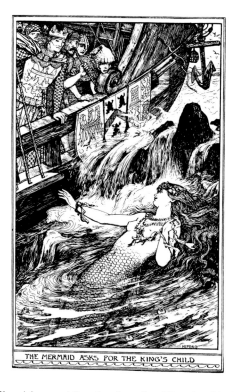

The Mermaid asks for the King's Child

"The Mermaid and the Boy," *The Brown Fairy Book*
H. J. FORD, 1904

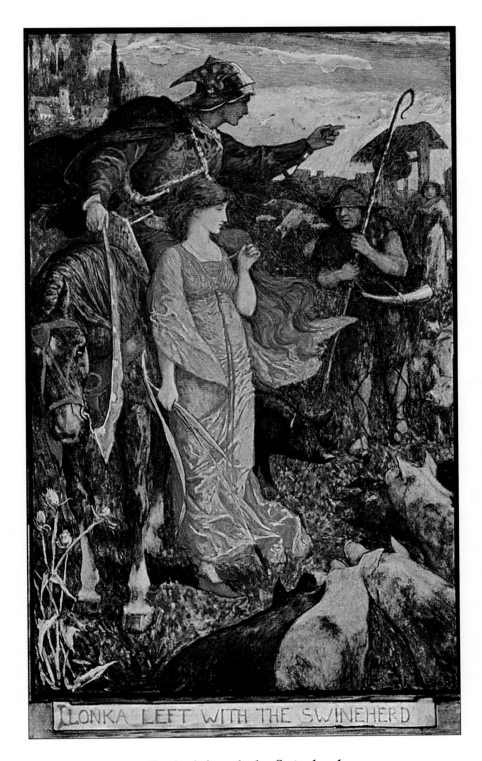

ILONKA LEFT WITH THE SWINEHERD

Ilonka left with the Swineherd

"Lovely Ilonka," *The Crimson Fairy Book*
H. J. FORD, 1903

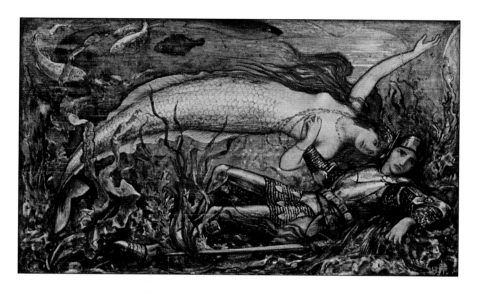

"Listen, Listen!" said the Mermaid to the Prince

"The Mermaid and the Boy," *The Brown Fairy Book*
H. J. FORD, 1904

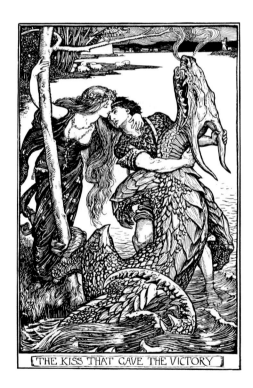

THE KISS THAT GAVE THE VICTORY

The Kiss that gave the Victory

"The Prince and the Dragon," *The Crimson Fairy Book*
H. J. FORD, 1903

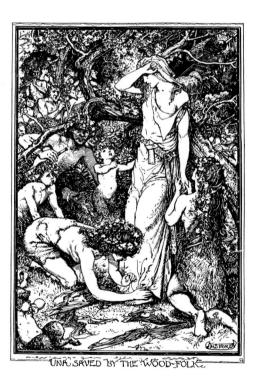

UNA SAVED BY THE WOOD-FOLK

Una saved by the Wood-folk

"Una and the Lion," *The Red Romance Book*
H. J. FORD, 1905

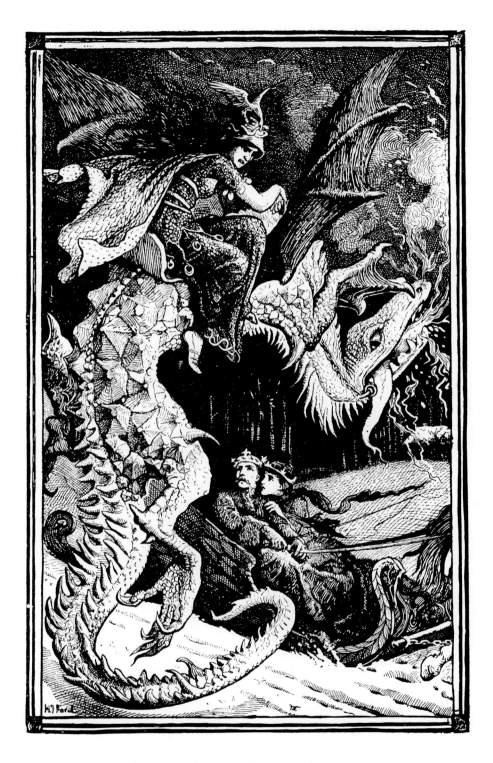

Gorgonzola flies off on her Dragon

"Heart of Ice," The Green Fairy Book
H. J. FORD, 1892

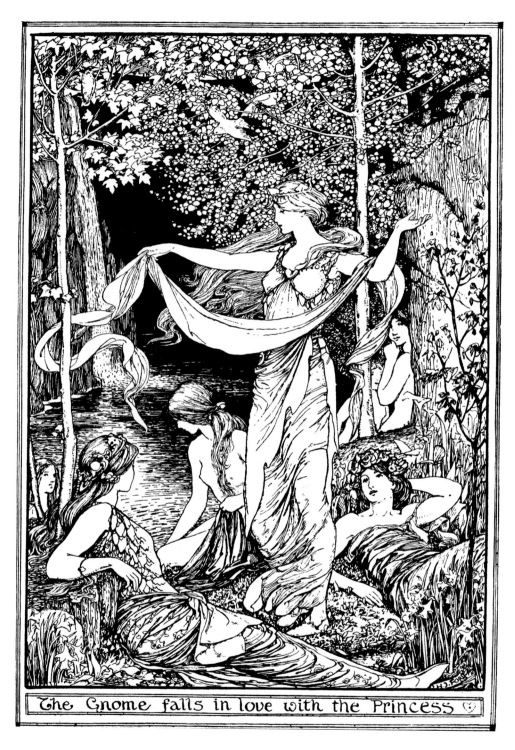

The Gnome falls in love with the Princess

The Gnome falls in love with the Princess

"Rübezahl," *The Brown Fairy Book*
H. J. FORD, 1904

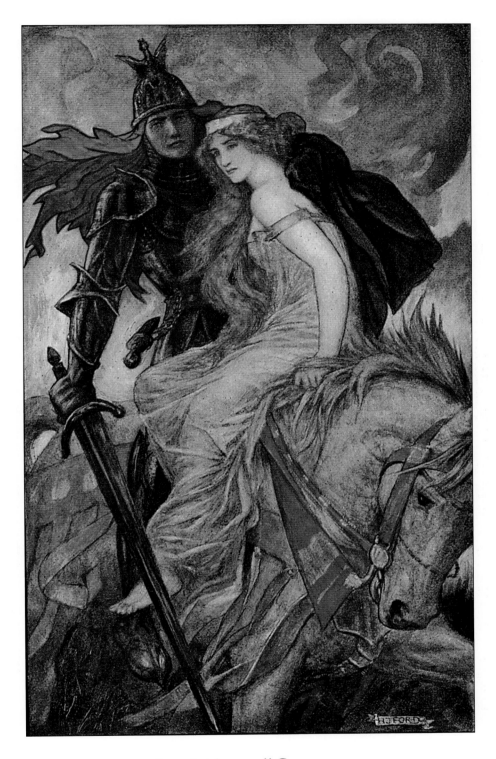

Lancelot bears off Guenevere

"Lancelot and Guenevere," *The Book of Romance*
H. J. Ford, 1903

"Are you not sometimes called Rumpelstilzchen?"

"Rumpelstilzchen," *The Fairy Book; The Best Popular Stories Selected and Rendered Anew*
WARWICK GOBLE, 1913

WARWICK GOBLE, 1862–1943
The Fairy Book; The Best Popular Stories Selected and Rendered Anew, 1913

The British artist Warwick Goble arrived at book illustration after a strong start as a magazine illustrator in the 1890s. His important early work includes the first illustrations to accompany H. G. Wells's *War of the Worlds* (1897). Like Edmund Dulac, Goble had a strong interest in imagery of the Far East, and it became something of a specialty for him late in his career. On the strength of his work on children's books, Goble was hired by the publishing house Macmillan as a resident illustrator in 1909; the artist thereby had an annual gift-book assignment that allowed him to create some of his best works for titles that suited both his interests and his strengths. His first book assignment for Macmillan was illustrations for Charles Kingsley's *The Water Babies*. In years to follow, Goble produced images for a variety of fairy and folk-tale titles. *The Fairy Book; The Best Popular Stories Selected and Rendered Anew* (1913) provided the opportunity for Goble to depict some of the best classic stories from Grimm, Andersen, and others.

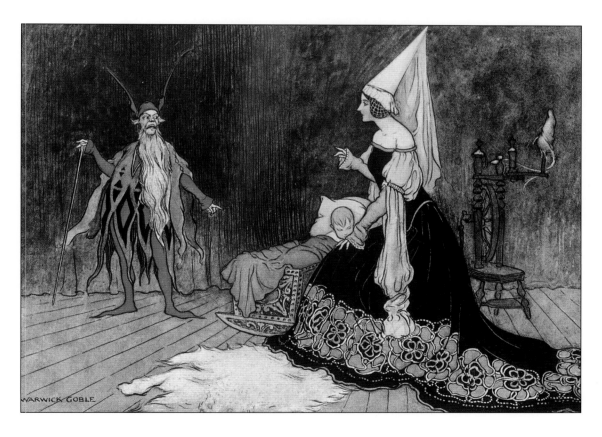

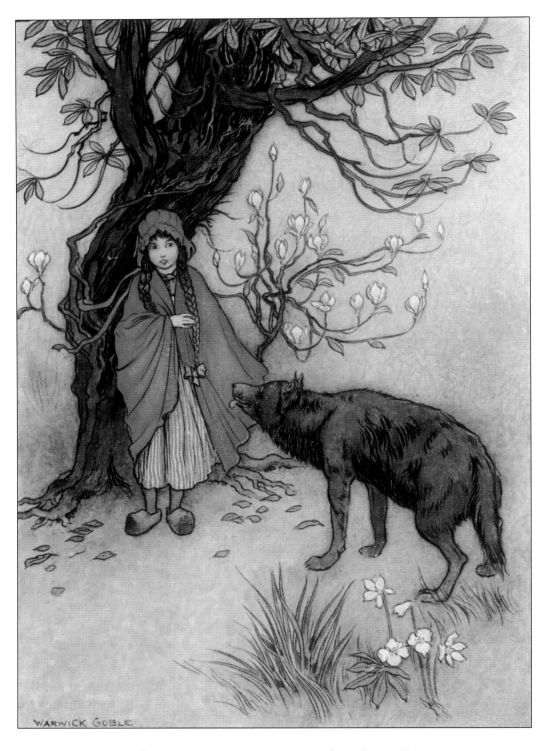

"Is it very far from hence?" asked the wolf

"Little Red-Riding Hood," *The Fairy Book; The Best Popular Stories Selected and Rendered Anew*
WARWICK GOBLE, 1913

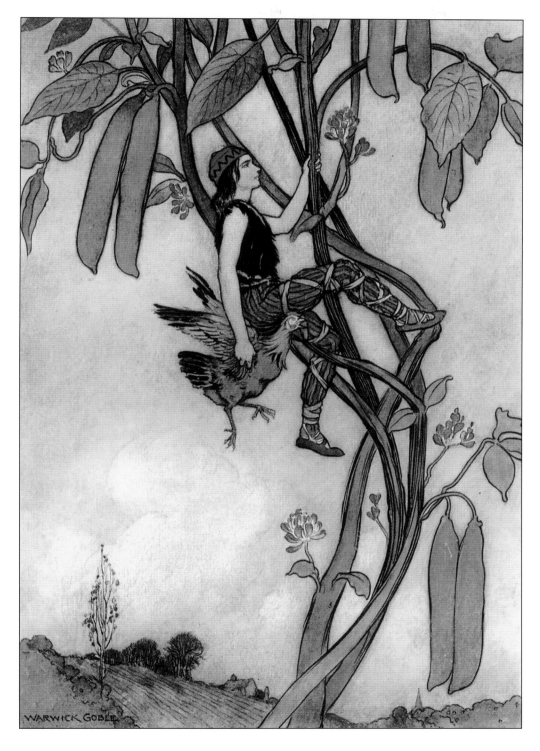

**Jack . . . seized the hen, and ran off with her, . . .
reached the top of the bean-stalk, which he descended in safety**

"Jack and the Bean-Stalk," *The Fairy Book; The Best Popular Stories Selected and Rendered Anew*
WARWICK GOBLE, 1913

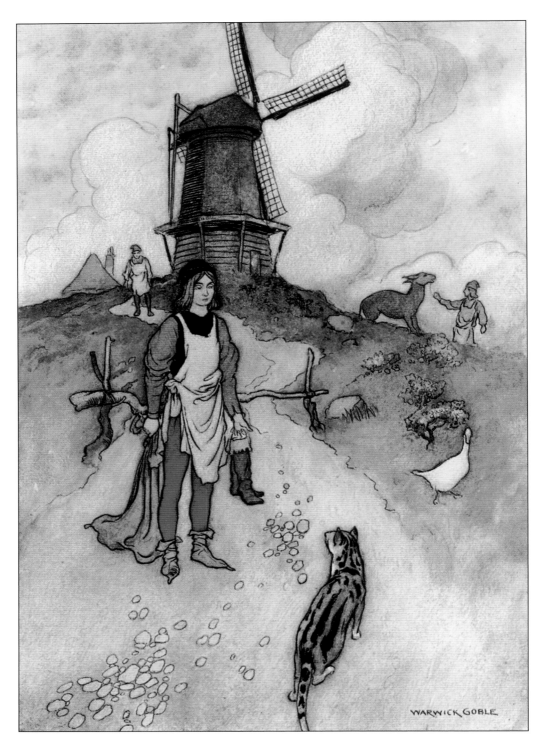

**"You have but to give me a sack, and a pair of boots such as
gentlemen wear when they go shooting"**

"Puss in Boots," *The Fairy Book; The Best Popular Stories Selected and Rendered Anew*
WARWICK GOBLE, 1913

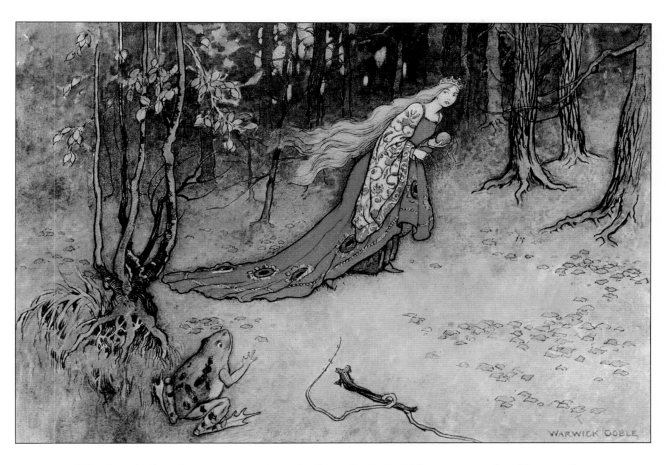

The king's daughter was overjoyed when she beheld her pretty plaything again, picked it up, and ran away with it

"The Frog-Prince," *The Fairy Book; The Best Popular Stories Selected and Rendered Anew*
WARWICK GOBLE, 1913

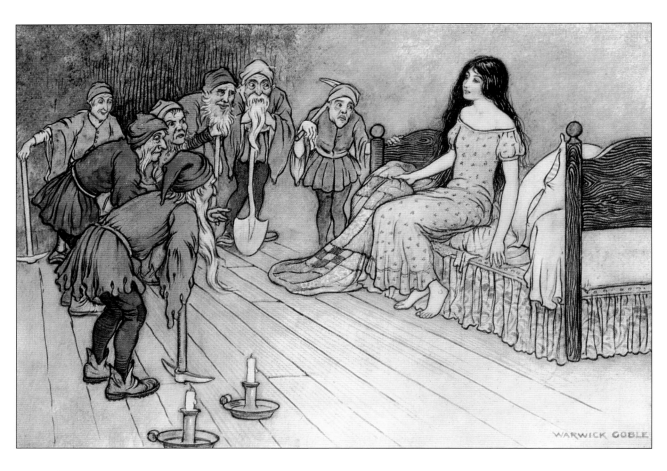

They were very friendly, however, and inquired her name. "Snowdrop," answered she

"Little Snowdrop," *The Fairy Book; The Best Popular Stories Selected and Rendered Anew*
WARWICK GOBLE, 1913

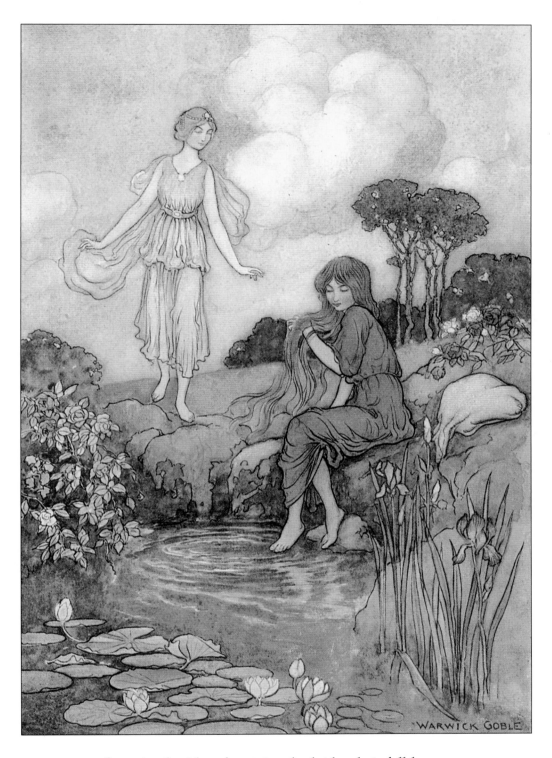

**Stopping beside a fountain, she let her hair fall loose,
and dipped her weary feet in the cool water**

"The Blue Bird," *The Fairy Book; The Best Popular Stories Selected and Rendered Anew*
WARWICK GOBLE, 1913

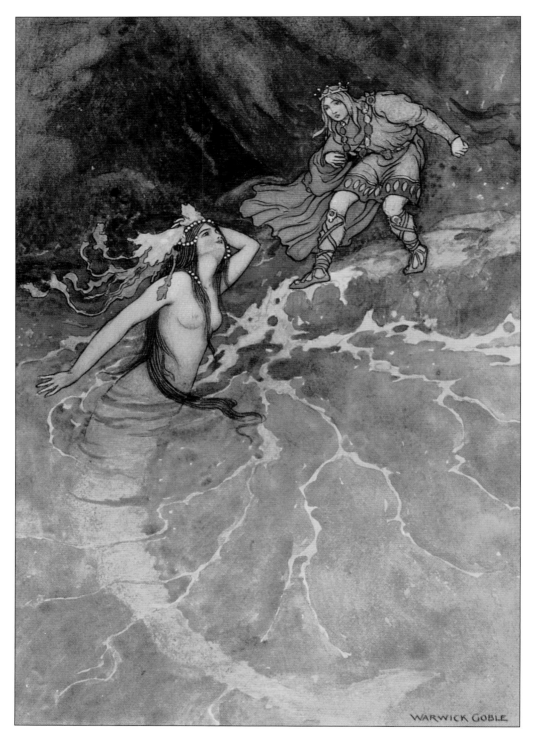

**There, one day, he heard a voice, and presently after was surprised
by the appearance of a mermaid**

"The Yellow Dwarf," The Fairy Book: The Best Popular Stories Selected and Rendered Anew
WARWICK GOBLE, 1913

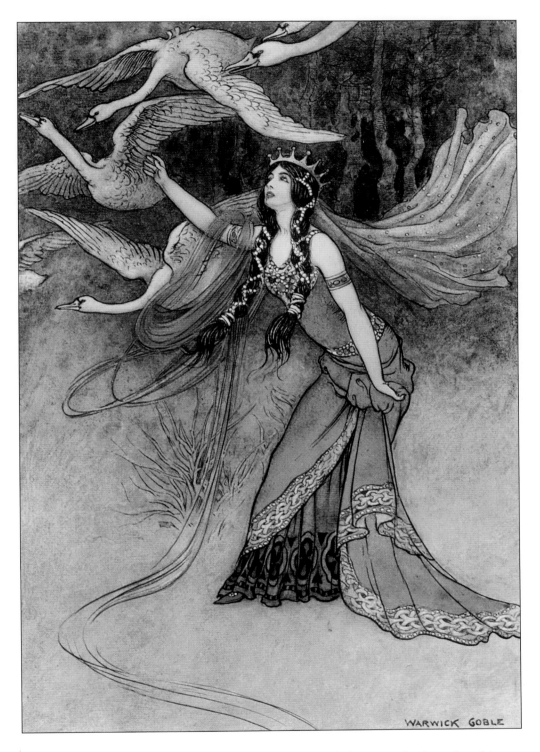

The queen threw one of the shirts over each of them, and when the shirts touched their bodies, they were changed into swans, and flew away over the wood

"The Six Swans," *The Fairy Book; The Best Popular Stories Selected and Rendered Anew*
WARWICK GOBLE, 1913

He had silver mail and a silver saddle and bridle

"The Princess on the Glass Hill," *Norse Fairy Tales*
Reginald Knowles, 1910

Reginald Knowles, 1879–1950
Norse Fairy Tales, 1910

Along with his brother Horace, Reginald Knowles created some memorable images for this collection of Norse fairy tales. Their work together offered glimpses of the fairy realm or of heroic topics (if not a hybrid of the two). Decoration was also a constant element in Knowles's books, and Reginald's work as a book designer was often characterized by ornate scrollwork or delicate leaf forms. When given the opportunity to combine his decorative and illustrative arts, as in the title page of this source volume, Reginald Knowles produced truly unique pieces.

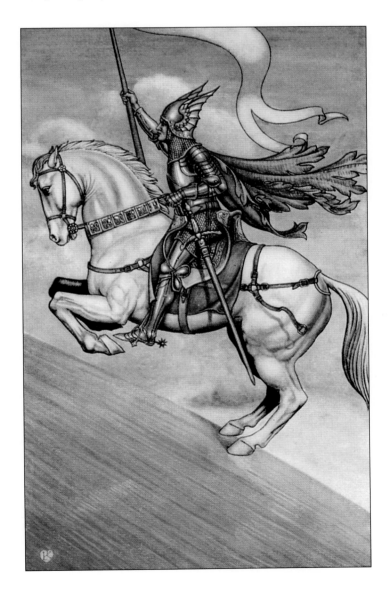

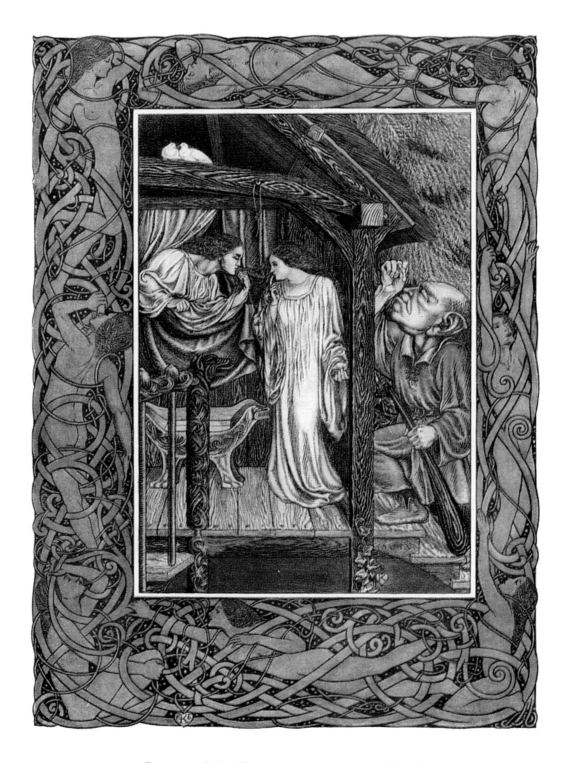

Boots and the Princess outwitting the Troll

"Boots and the Troll," *Norse Fairy Tales*
Reginald Knowles, 1910

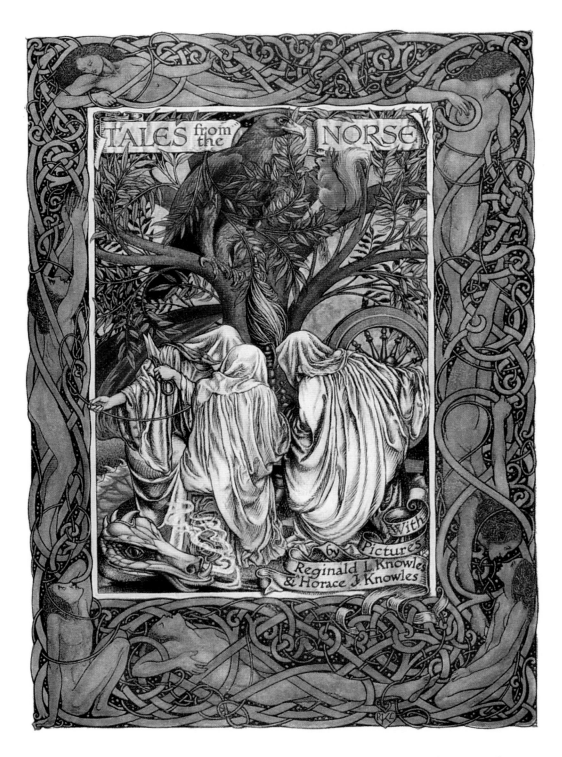

**The Squirrel, messenger of the Norse Gods, carrying tales between the
Dragon who guards the Well of Knowledge, and the Eagle who dwells in the mystic tree
Yggdrasil, beneath whose branches sit the Three Norns spinning the fates of men**

Title page, *Norse Fairy Tales*
Reginald Knowles and Horace Knowles, 1910

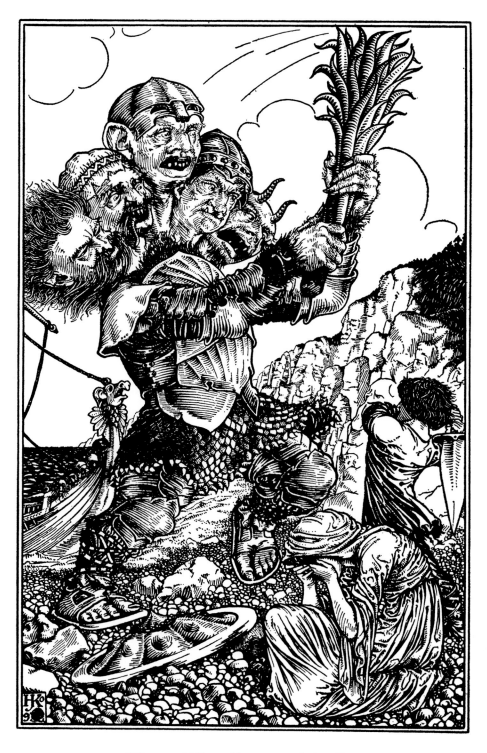

"Fire and Flame!" screamed the Ogre

"Shortshanks," Norse Fairy Tales
Reginald Knowles, 1910

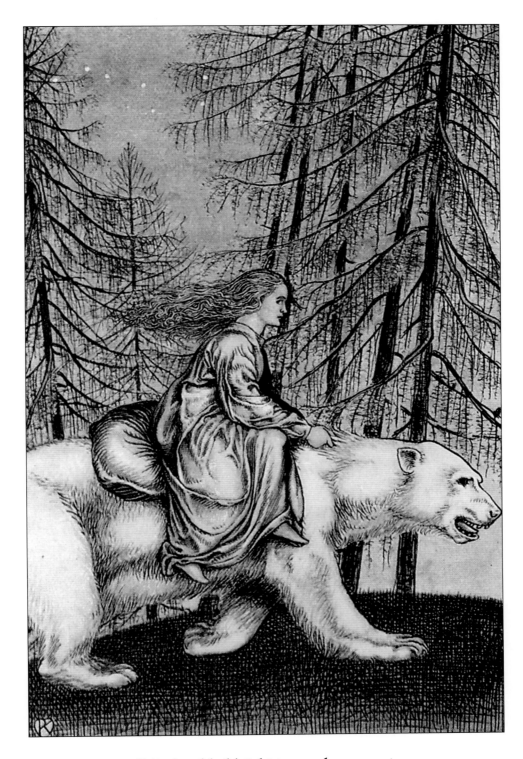

**"Mind and hold tight to my shaggy coat,
and then there's nothing to fear," said the Bear**

"East o' the sun and West o' the Moon," *Norse Fairy Tales*
Reginald Knowles, 1910

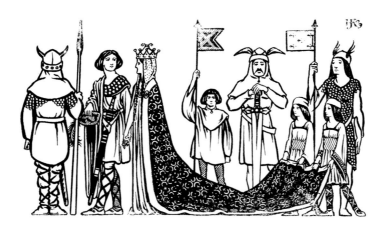

The wedding procession

"The Best Wish," *Norse Fairy Tales*
Reginald Knowles, 1910

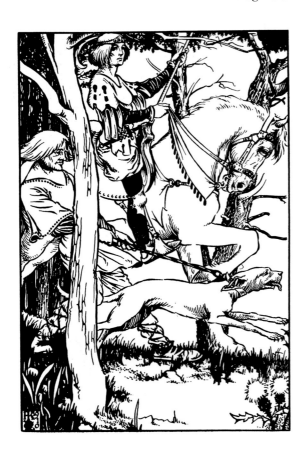

The young King came riding across the moor and saw her (Left and Right)

"The Twelve Wild Ducks," *Norse Fairy Tales*
Reginald Knowles, 1910

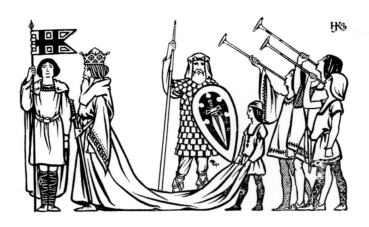

The wedding procession

"The Best Wish," *Norse Fairy Tales*
Reginald Knowles, 1910

When everything was ready, down came the Trolls (Left and Right)

"The Cat on the Dovrefell," *Norse Fairy Tales*
Reginald Knowles, 1910

"Tell me the way, then," she said, "and I'll search you out"

"East of the Sun and West of the Moon," *East of the Sun and West of the Moon*
Kay Nielsen, 1914

KAY NIELSEN, 1886–1957
East of the Sun and West of the Moon, 1914
In Powder and Crinoline, 1913

Like Hans Christian Andersen, Kay Nielsen was a son of Denmark. Andersen's tales, as well as Norse sagas, were a part of Nielsen's childhood, and it is not surprising that they were the subjects of some of his large-scale projects. Nielsen's stylized illustrations combine rather flat figures in ornate settings, with a hint of art deco design. A love of decoration also played a major role in his art, expressed through a vibrant variety of patterns. After World War I, there was a decrease in quality book production, and Kay Nielsen tried his hand at stage design before producing several more book projects in the late 1920s and early '30s.

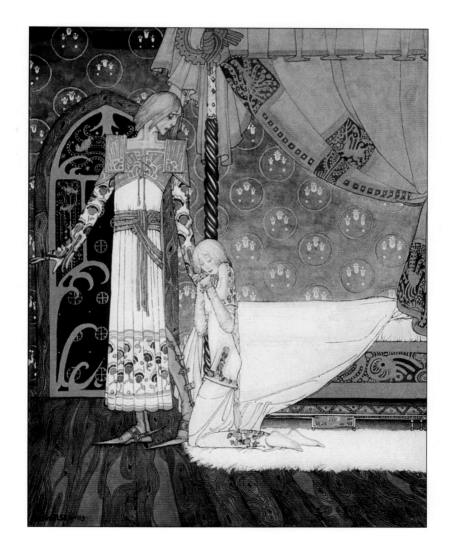

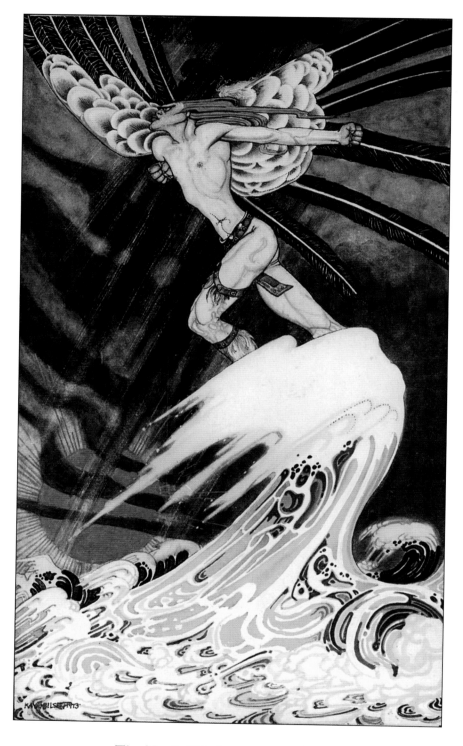

The North Wind goes over the sea

"East of the Sun and West of the Moon," *East of the Sun and West of the Moon*
Kay Nielsen, 1914

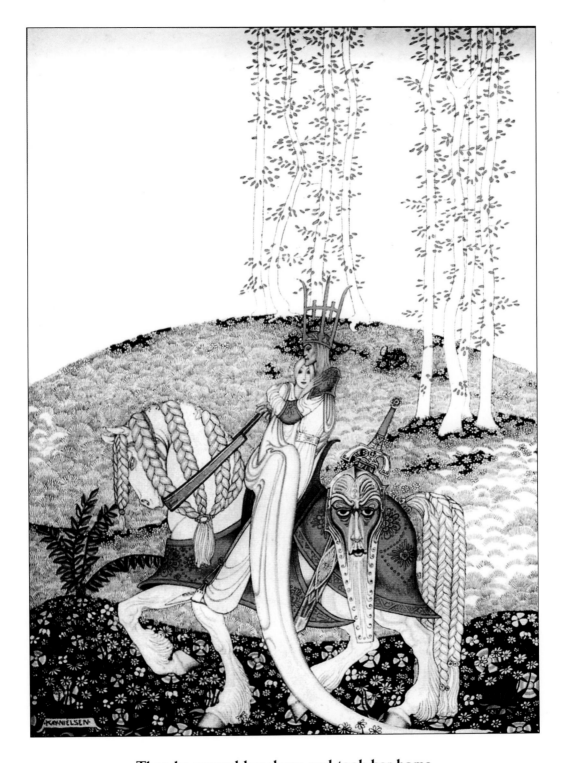

Then he coaxed her down and took her home

"The Lassie and Her Godmother," *East of the Sun and West of the Moon*
Kay Nielsen, 1914

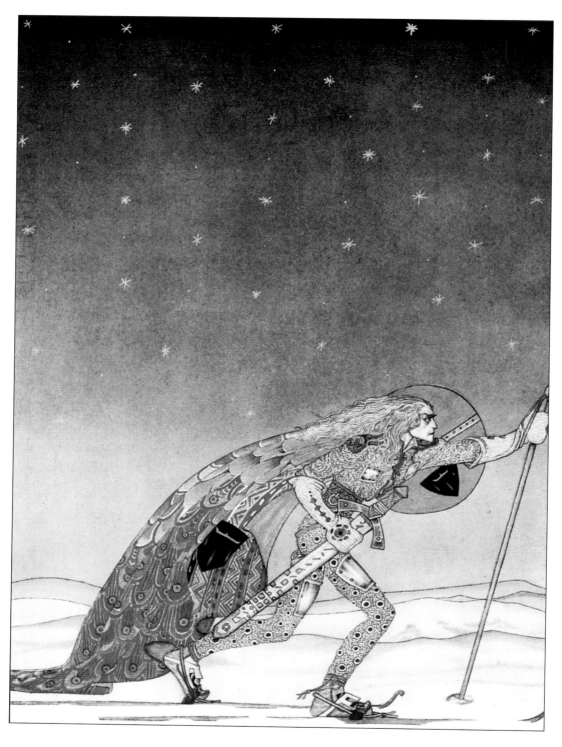

So the man gave him a pair of snowshoes

"The Three Princesses of Whiteland," *East of the Sun and West of the Moon*
Kay Nielsen, 1914

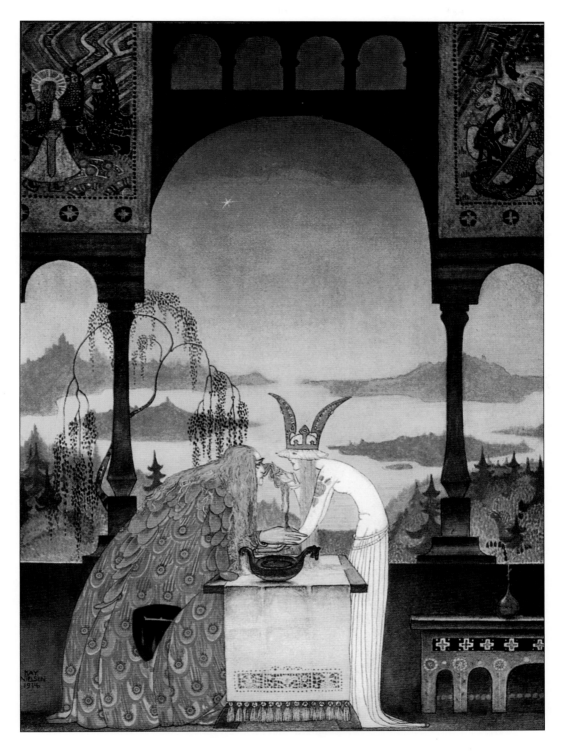

**The King went into the Castle, and at first his Queen didn't know him,
he was so wan and thin, through wandering so far and being so woeful**

"The Three Princesses of Whiteland," *East of the Sun and West of the Moon*
Kay Nielsen, 1914

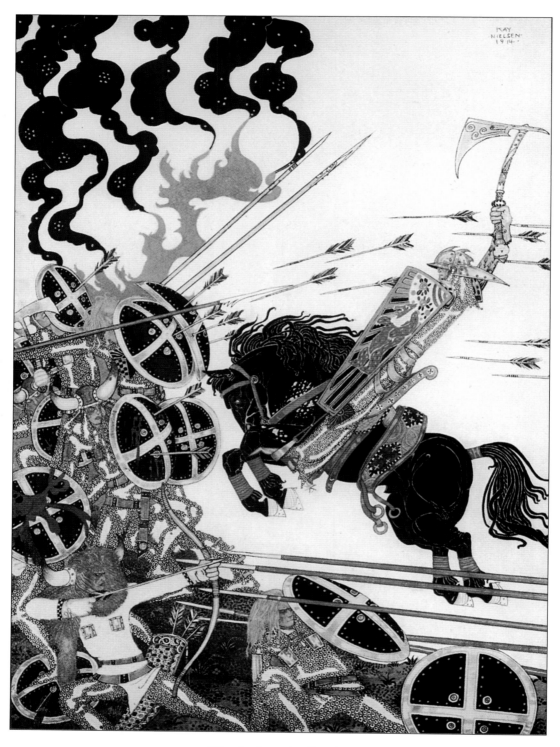

The Lad in the Battle

"The Widow's Son," *East of the Sun and West of the Moon*
Kay Nielsen, 1914

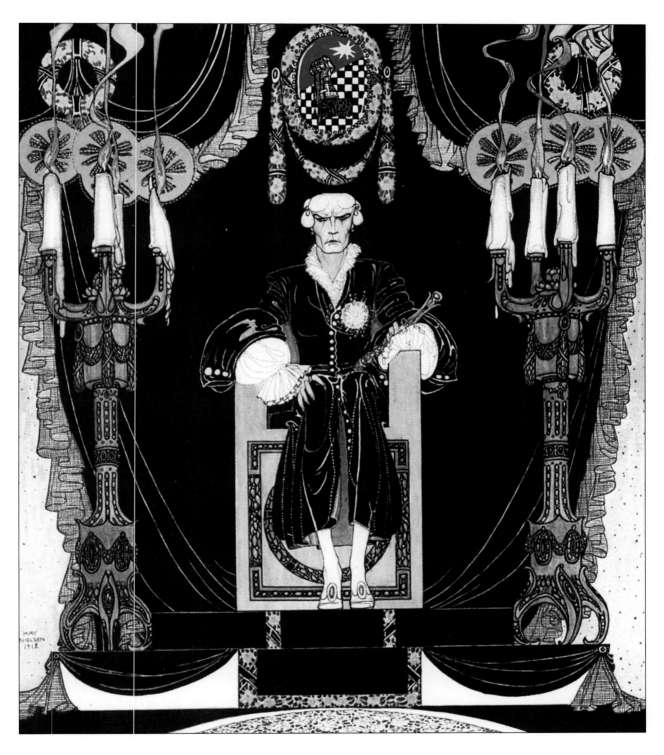

And there on a throne all covered with black sat the Iron King

"Minon-Minette," *In Powder and Crinoline*
Kay Nielsen, 1913

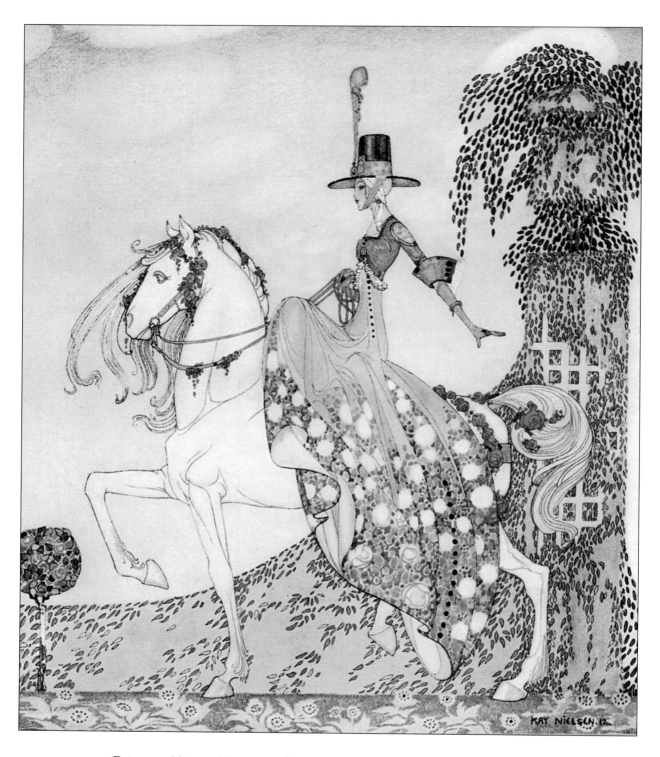

Princess Minon-Minette rides out in the world to find Prince Souci

"Minon-Minette," *In Powder and Crinoline*
Kay Nielsen, 1913

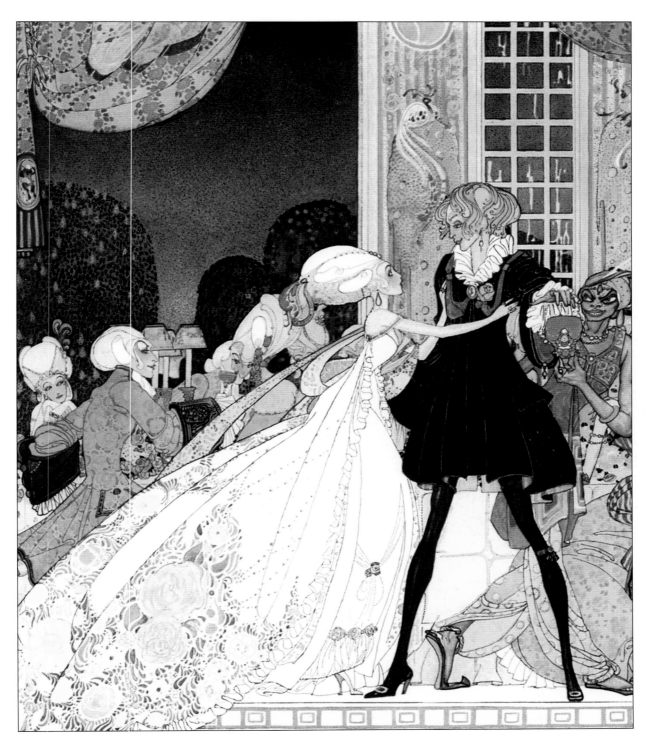

"Don't drink!" cried out the little Princess, springing to her feet;
"I would rather marry a gardener!"

"The Twelve Dancing Princesses," *In Powder and Crinoline*
Kay Nielsen, 1913

"If that will suit you, we will sit down and eat it together." So they sat down

"The Golden Goose," *Grimm's Fairy Tales*
NOEL POCOCK, n.d.

NOEL POCOCK, 1880–1955
Grimm's Fairy Tales, (n.d.)

The work of Noel Pocock (active 1910–1930) displays the influence of the American illustrator Maxfield Parrish. Centered heavily on the figure, Pocock's work reveals a realistic treatment, despite the exaggerated emotions and expression; small touches of pattern and color also pull in the viewer's attention. The simple settings of Pocock's illustrations are enhanced by a canny use of lighting to add dimension in darkly wooded areas.

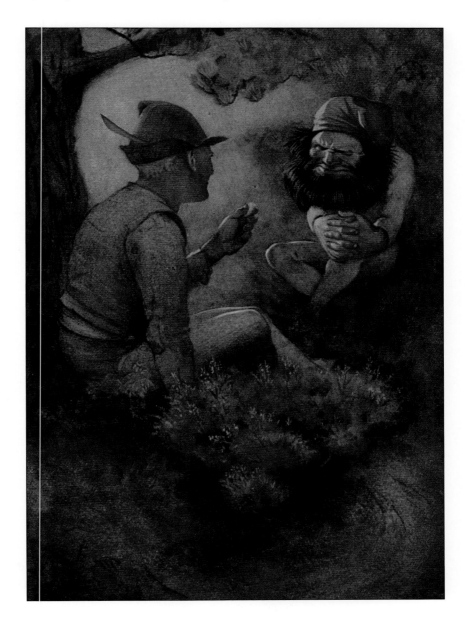

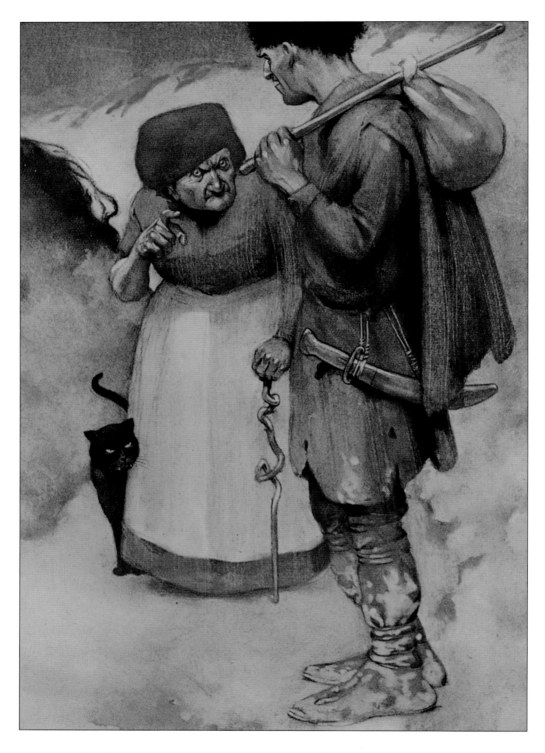

**As he was traveling through a wood, he met an old woman,
who asked him where he was going**

"The Twelve Dancing Princesses," *Grimm's Fairy Tales*
NOEL POCOCK, n.d.

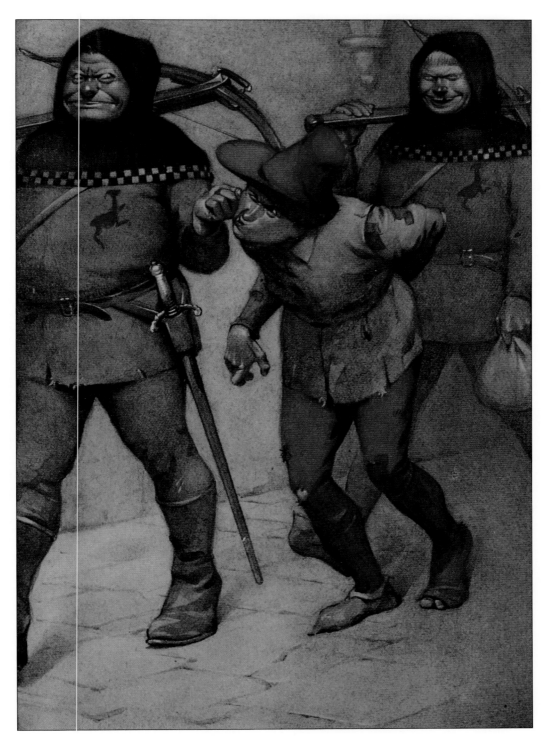

They said he was a thief, and took him to the Judge

"The Grateful Beasts," *Grimm's Fairy Tales*
Noel Pocock, n.d.

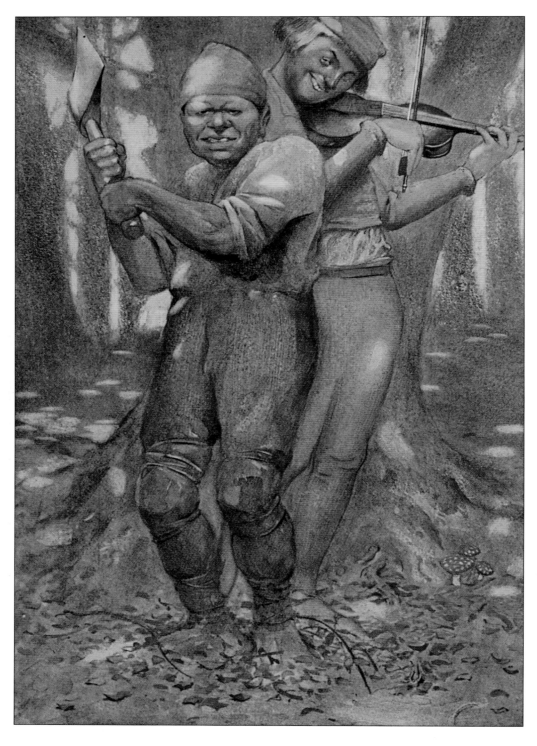

So he stood before the musician with his great axe

"The Wonderful Musician," *Grimm's Fairy Tales*
NOEL POCOCK, n.d.

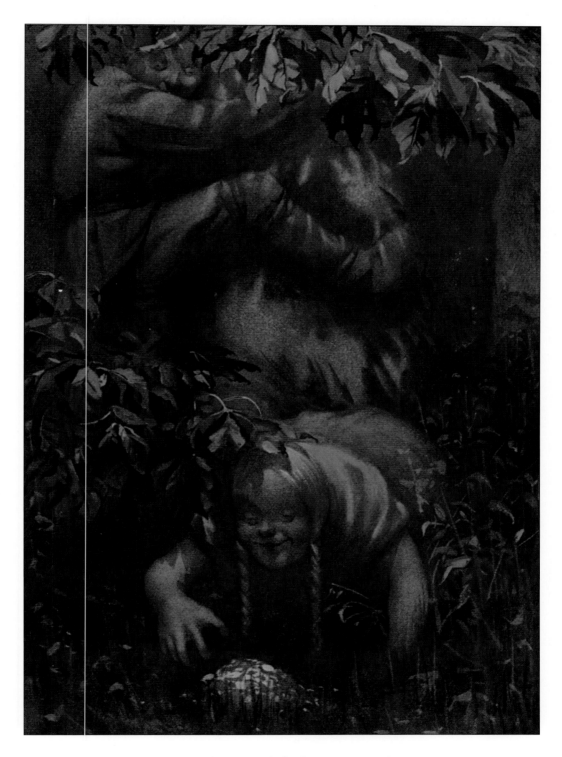

**When Frederick and Catherine came down,
there they found all their money safe and sound**

"Frederick and Catherine," *Grimm's Fairy Tales*
NOEL POCOCK, n.d.

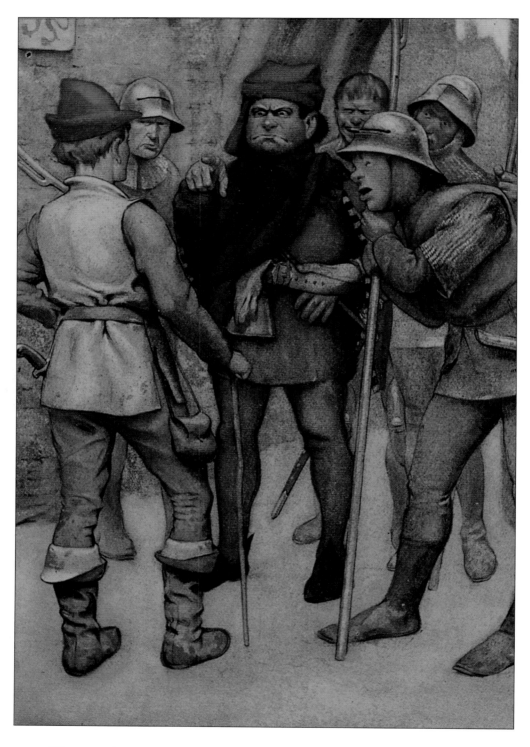

The guard of the gate stopt him, and asked what trade he followed

"The Giant with the Three Golden Hairs," *Grimm's Fairy Tales*
NOEL POCOCK, n.d.

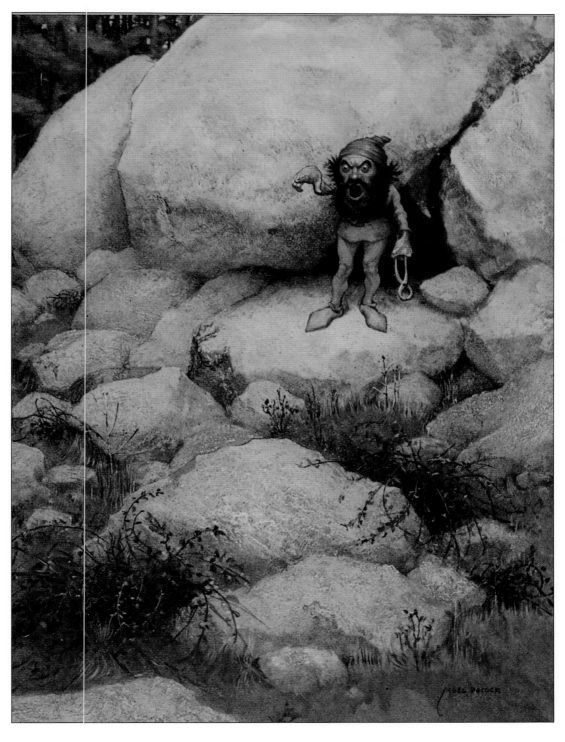

As he looked around there stood above him on one of the rocks a little dwarf

"The Water of Life," Grimm's Fairy Tales
NOEL POCOCK, n.d.

"Somebody has been at my porridge, and has eaten it all up!"

"The Story of the Three Bears," *English Fairy Tales*
ARTHUR RACKHAM, 1918

ARTHUR RACKHAM, 1867–1939
The Allies' Fairy Book, 1916
English Fairy Tales, 1918
Snowdrop and Other Tales by the Brothers Grimm, 1920
Hansel and Grethel and Other Tales by the Brothers Grimm, 1920

If there were a leading figure among the illustrators of fairy-tale books, it certainly would be the British artist Arthur Rackham. Starting his career slowly and with caution, Rackham nevertheless emerged from newspaper and magazine work in 1905 with an industry-changing treatment of Washington Irving's tale *Rip Van Winkle,* which contained an unprecedented fifty-one color plates. The success of this book helped create the market for which many of these illustrated books were produced—the gift-book. For the next decade and later, Rackham created lavishly illustrated books for each holiday season; he earned a lasting reputation for his subtle color palette and expressive line work.

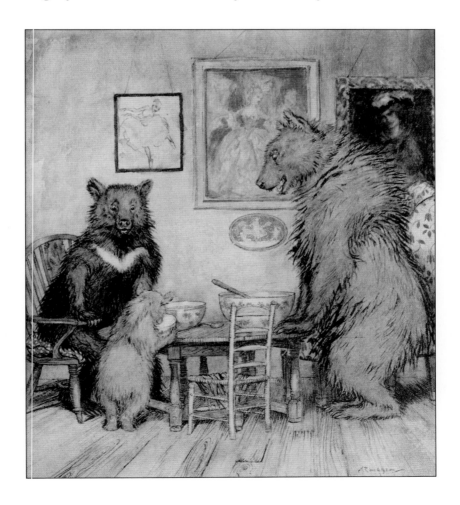

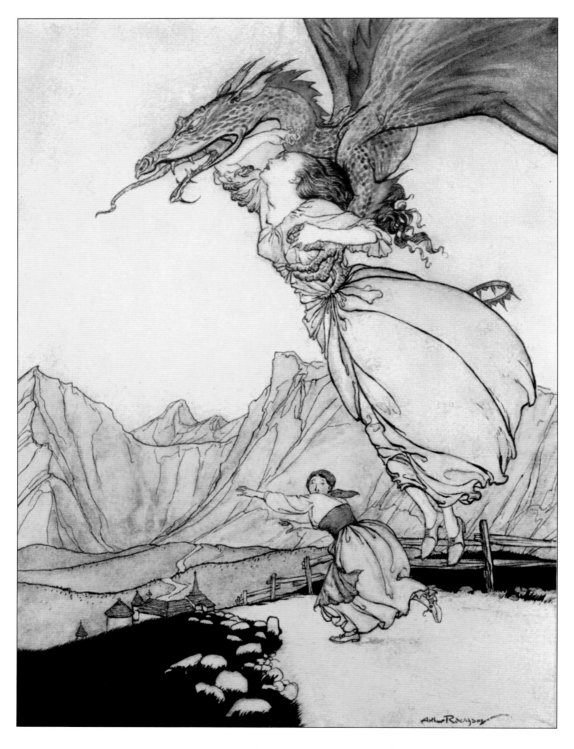

The dragon flew out and caught the queen on the road and carried her away

"The Golden Apple-Tree and the Nine Peahens," *The Allies' Fairy Book*
ARTHUR RACKHAM, 1916

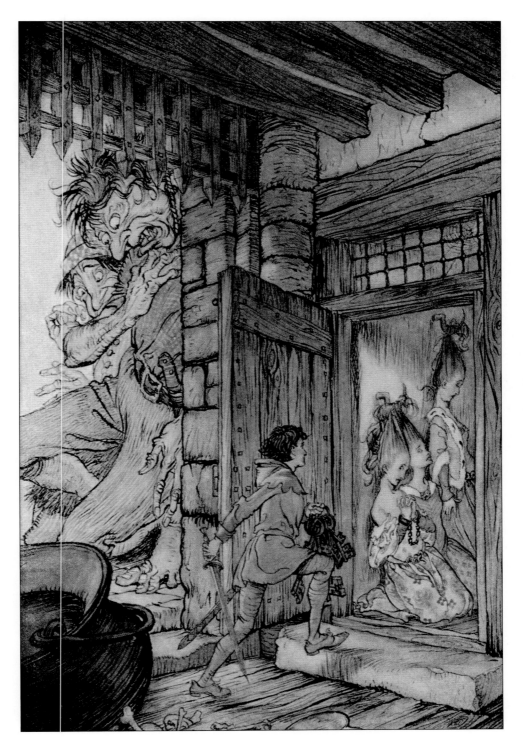

Taking the keys of the castle, Jack unlocked all the doors

"Jack the Giant-Killer," *English Fairy Tales*
ARTHUR RACKHAM, 1918

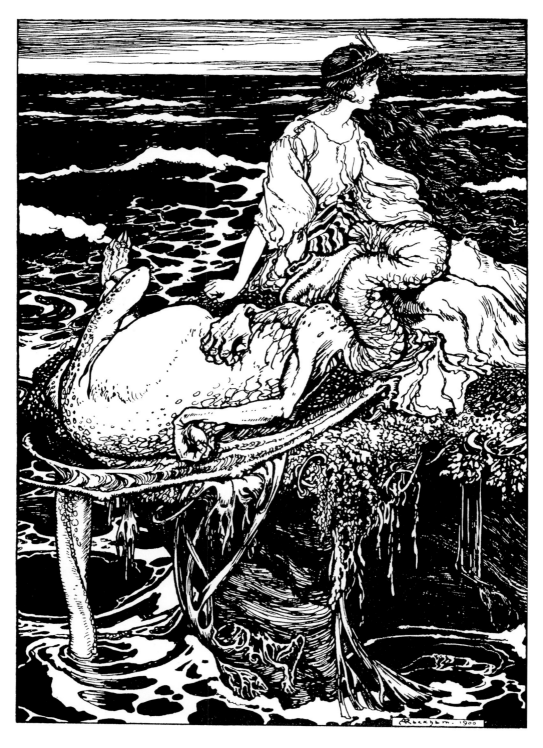

**They found the Princess still on the rock, but the dragon
was asleep with his head on her lap**

"The Four Clever Brothers," *Snowdrop and Other Tales by the Brothers Grimm*
ARTHUR RACKHAM, 1920

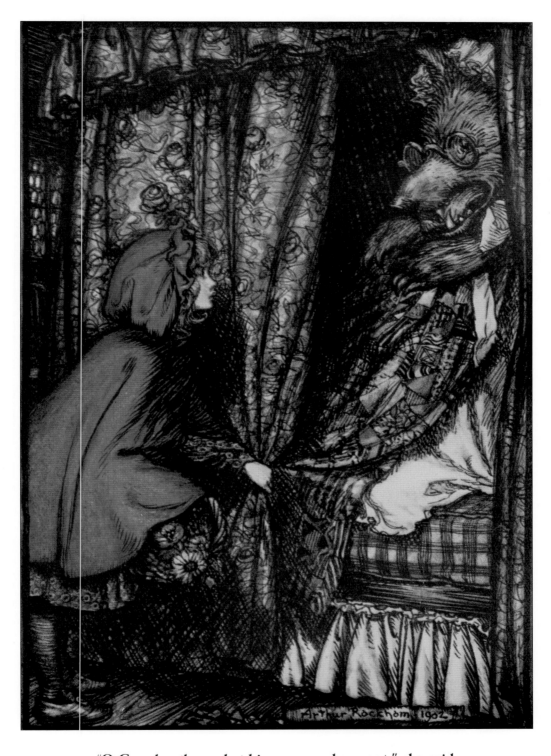

"O Grandmother, what big ears you have got," she said

"Red Riding Hood," *Hansel and Grethel and Other Tales by the Brothers Grimm*
ARTHUR RACKHAM, 1920

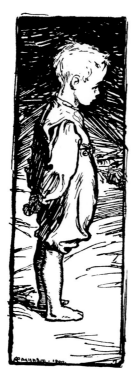

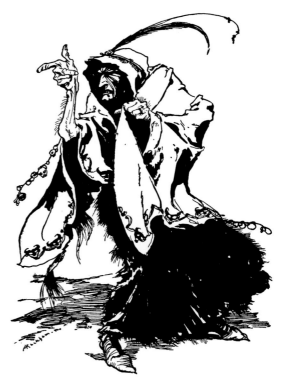

Headpiece

"The Old Man and his Grandson"
Hansel and Grethel and Other Tales by the Brothers Grimm
ARTHUR RACKHAM, 1920

The Thirteenth Fairy

"Briar Rose," *Snowdrop and Other Tales by
the Brothers Grimm*
ARTHUR RACKHAM, 1920

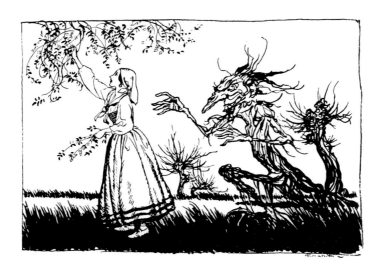

Headpiece

"What Came of Picking Flowers," *The Allies' Fairy Book*
ARTHUR RACKHAM, 1916

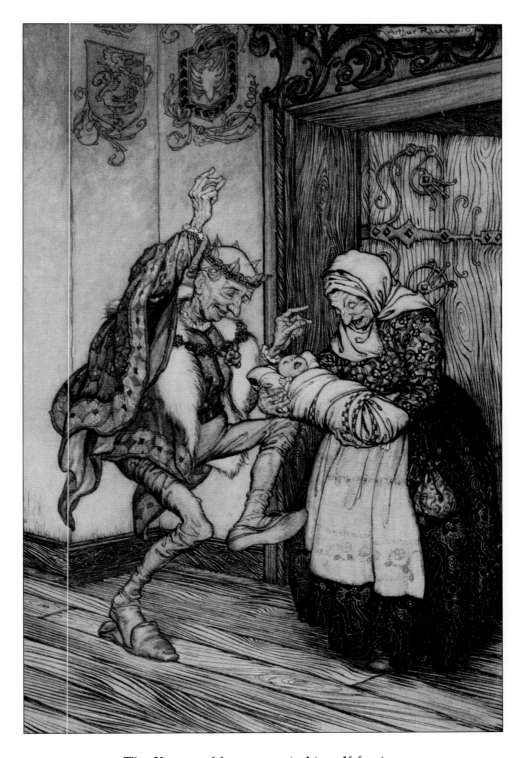

The King could not contain himself for joy

"Briar Rose," Snowdrop and Other Tales by the Brothers Grimm
ARTHUR RACKHAM, 1920

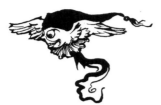

Detail, Endpiece
*"The Dog and the Sparrow," Hansel and Grethel
and Other Tales by the Brothers Grimm*
ARTHUR RACKHAM, 1920

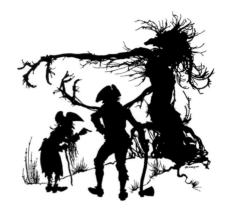

**There stands an old tree; cut it down,
and you will find something at the roots**
*"The Golden Goose," Snowdrop and
Other Tales by the Brothers Grimm*
ARTHUR RACKHAM, 1920

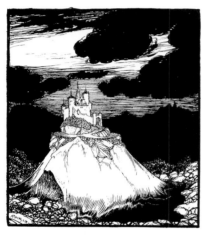

The Golden Castle of Stromberg
*"The Raven," Hansel and Grethel and
Other Tales by the Brrothers Grimm*
ARTHUR RACKHAM, 1920

Detail, Endpiece
*"The Battle of the Birds,"
The Allies' Fairy Book*
ARTHUR RACKHAM, 1916

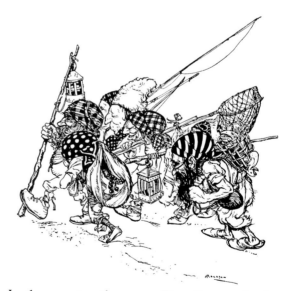

In the evening the seven Dwarfs came back
*"Snowdrop," Snowdrop and Other Tales by
the Brothers Grimm*
ARTHUR RACKHAM, 1920

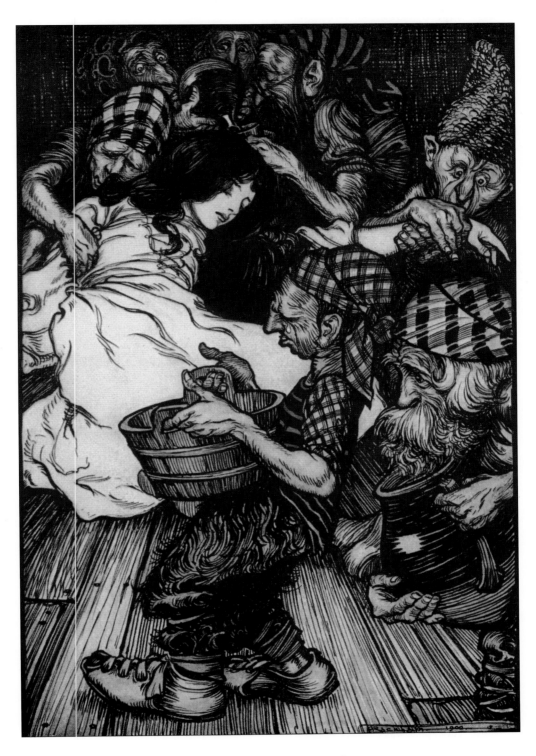

**The Dwarfs, when they came in the evening,
found Snowdrop lying on the ground**
"Snowdrop," Snowdrop and Other Tales by the Brothers Grimm
ARTHUR RACKHAM, 1920

[He] blew himself up like a ship in full sail

"The Ugly Duckling," *Hans Andersen's Fairy Tales and Wonder Stories*
LOUIS RHEAD, 1914

LOUIS RHEAD, 1857–1926
Hans Andersen's Fairy Tales and Wonder Stories, 1914

Born in England and educated both at home and in Paris, Louis Rhead was working as an illustrator in America by the mid 1880s. Rhead discovered that he had a real talent for poster design, and he received poster assignments from many of the leading New York publications. As the publishing boom turned towards illustrated books, Louis and his brothers, George and Frederick, adapted their styles and found assignments illustrating classic stories for the next twenty years. After 1900, book illustration became Louis Rhead's primary creative focus. Rhead produced illustrations for hundreds of black-and-white pieces in books such as *Swiss Family Robinson, Treasure Island, Tales of King Arthur, Robin Hood,* and the selection of pieces, presented here, from his *Hans Andersen's Fairy Tales and Wonder Stories.* Rhead's color work was unusual in that full-size line pieces of color images were printed elsewhere in the book.

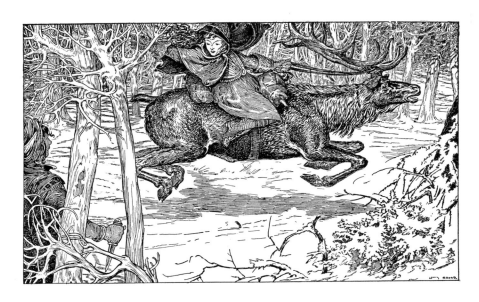

Gerda said farewell to the Robber-Maiden

"The Snow-Queen," *Hans Andersen's Fairy Tales and Wonder Stories*
LOUIS RHEAD, 1914

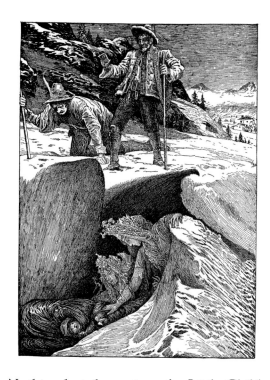

Nothing but the crying of a Little Child

"The Ice-Maiden," *Hans Andersen's Fairy Tales and Wonder Stories*
LOUIS RHEAD, 1914

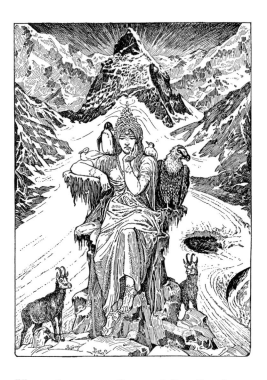

Here she sat and gazed fixedly down

"The Ice-Maiden," *Hans Andersen's Fairy Tales and Wonder Stories*
LOUIS RHEAD, 1914

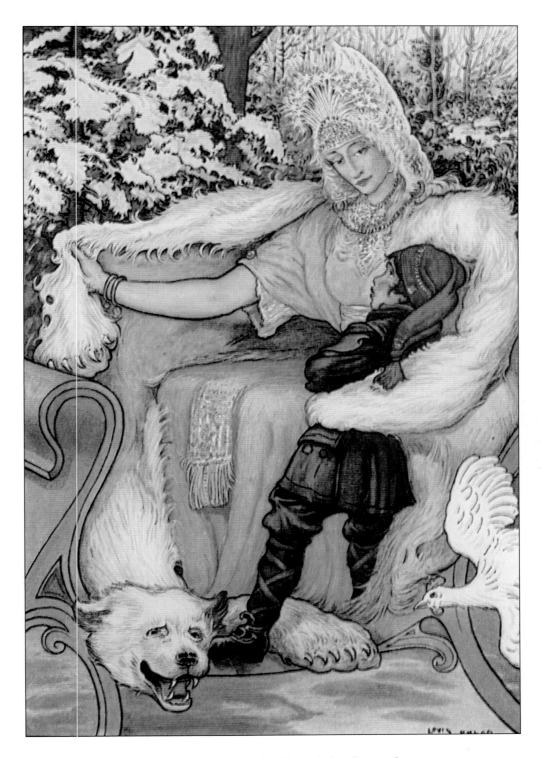

"Come under my bearskin," said the Snow-Queen

"The Snow-Queen," Hans Andersen's Fairy Tales and Wonder Stories
LOUIS RHEAD, 1914

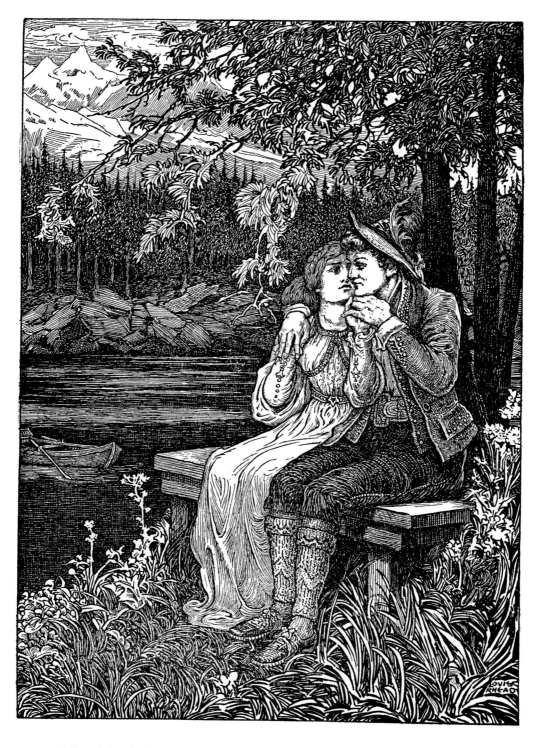

[They] looked into each other's eyes and held each other's hands

"The Ice-Maiden," *Hans Andersen's Fairy Tales and Wonder Stories*
Louis Rhead, 1914

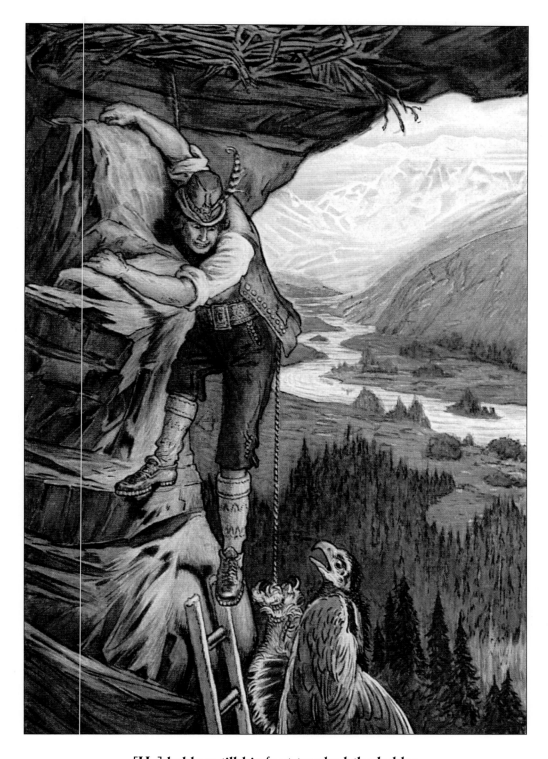

[He] held on till his foot touched the ladder

"The Ice-Maiden," *Hans Andersen's Fairy Tales and Wonder Stories*
LOUIS RHEAD, 1914

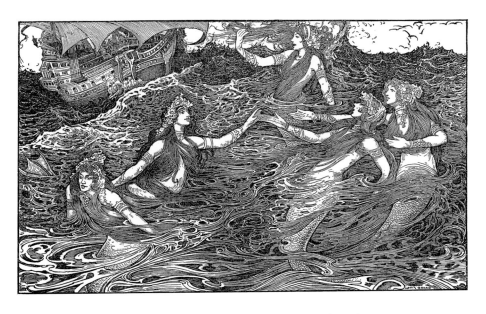

They swam before the ships and sang lovely songs

"The Little Sea-Maid," *Hans Andersen's Fairy Tales and Wonder Stories*
LOUIS RHEAD, 191

"This comes of wishing to have clean shoes"

"The Girl who trod upon bread,"
Hans Andersen's Fairy Tales and Wonder Stories
LOUIS RHEAD, 1914

Invited to a family concert

"The Toad," *Hans Andersen's Fairy Tales and
Wonder Stories*
LOUIS RHEAD, 1914

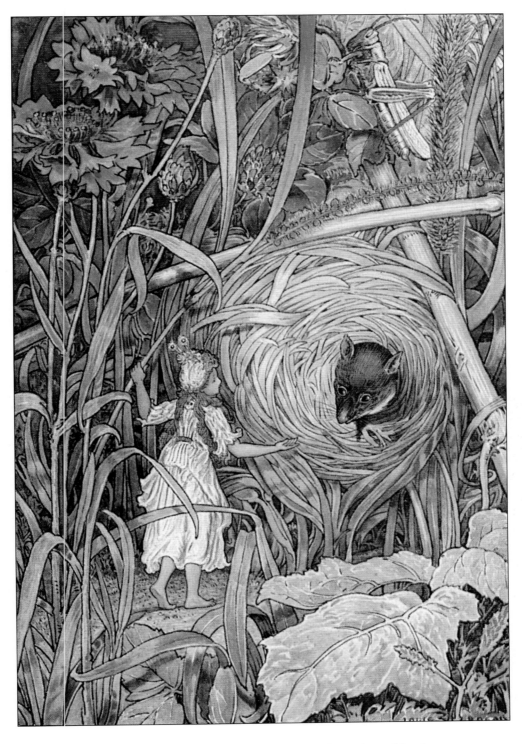

**Thumbling stood at the door and begged for a bit of barleycorn.
"You poor little creature," said the field-mouse**

"Thumbling," Hans Andersen's Fairy Tales and Wonder Stories
LOUIS RHEAD, 1914

**"He did not come to woo her," he said,
"He had only come to hear the wisdom of the princess"**

"The Snow Queen," Hans Andersen's Fairy Tales
WILLIAM HEATH ROBINSON, 1913

WILLIAM HEATH ROBINSON, 1872–1944
Hans Andersen's Fairy Tales, 1913

For the Robinson brothers, illustration was a family business. William Heath Robinson was the youngest of the three brothers, all of whom followed their father into the graphic arts, particularly illustration. William was by most measures the most successful of the three: Not only did he have a good run producing illustrations for the gift-book market during the early twentieth century, but he is even more highly regarded for the ingenious comics he drew in the years between the wars—a time when the popularity of the gift-book had declined, and many illustrators had drifted away from artistic endeavors. William Heath Robinson's book illustration work, especially for fairy tales, is among the best-loved imagery of the era.

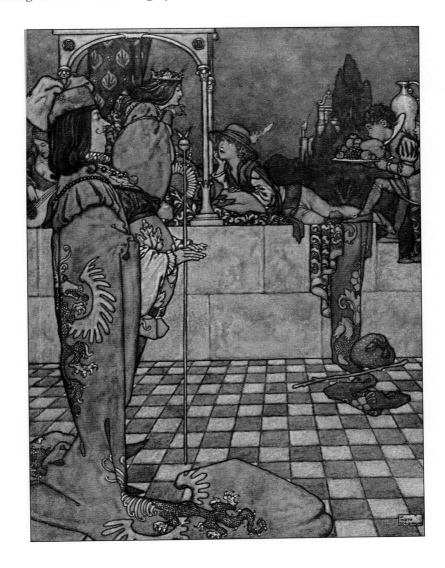

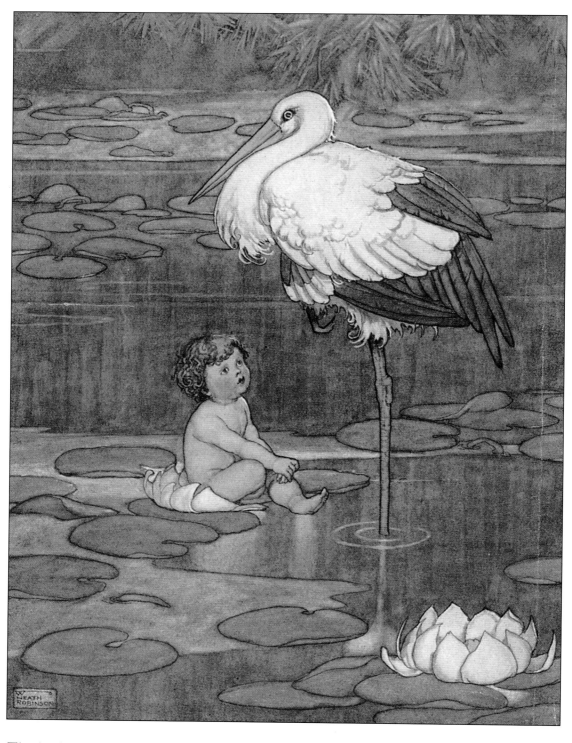

The bud opened into a full-blown flower, in the middle of which lay a beautiful child

"The Marsh King's Daughter," *Hans Andersen's Fairy Tales*
WILLIAM HEATH ROBINSON, 1913

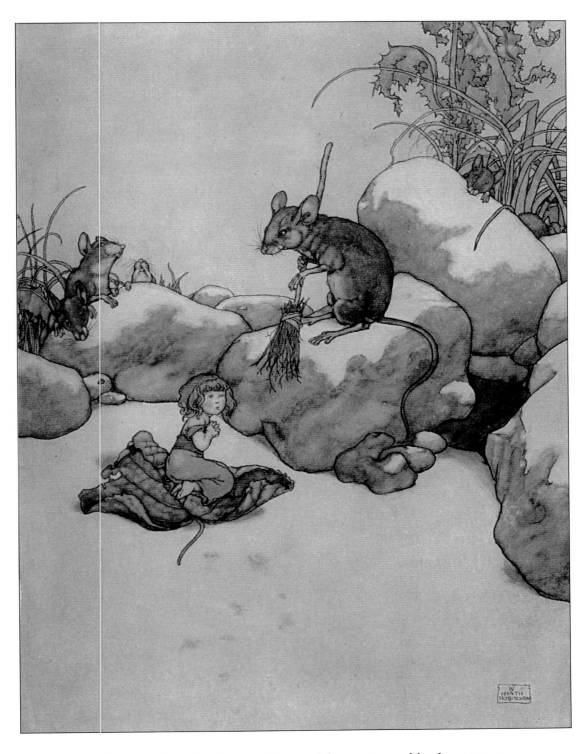

She stood at the door and begged for a piece of barley-corn

"Tommelise," Hans Andersen's Fairy Tales
WILLIAM HEATH ROBINSON, 1913

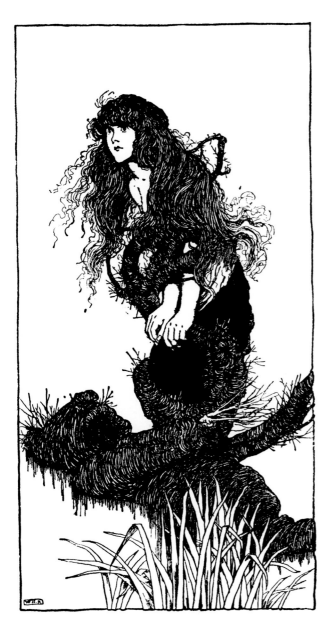

Father-stork

"The Storks," *Hans Andersen's Fairy Tales*
WILLIAM HEATH ROBINSON, 1913

It was he who pulled her down

"The Marsh King's Daughter,"
Hans Andersen's Fairy Tales
WILLIAM HEATH ROBINSON, 1913

The son lived merrily

"The Flying Trunk," *Hans Andersen's Fairy Tales*
WILLIAM HEATH ROBINSON, 1913

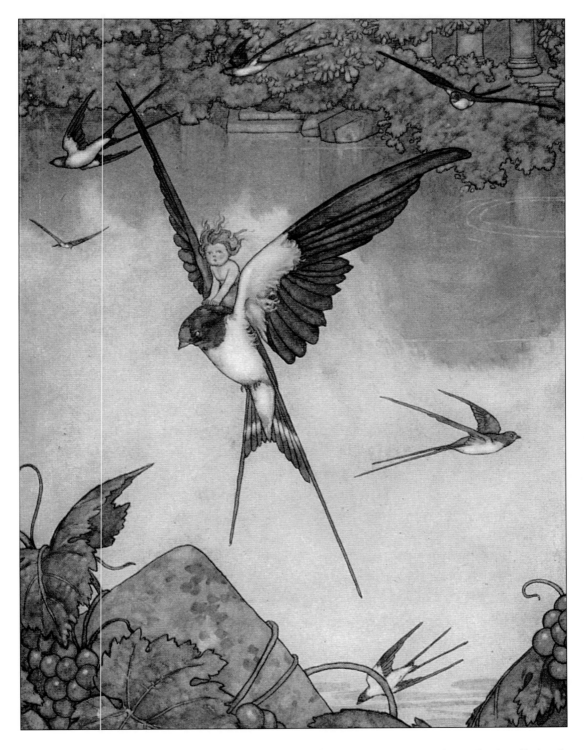

"Yes, I will go with thee!" said Tommelise, and she seated herself on the bird's back

"Tommelise," Hans Andersen's Fairy Tales
WILLIAM HEATH ROBINSON, 1913

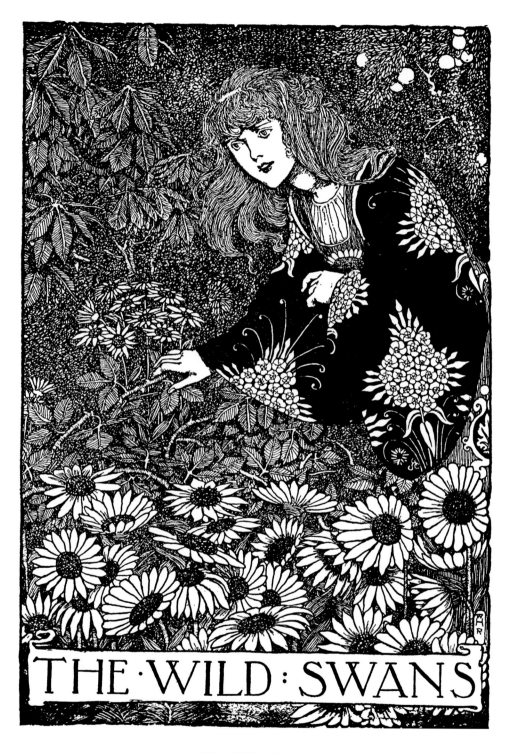

The Wild Swans

"The Wild Swans," *Hans Andersen's Fairy Tales*
WILLIAM HEATH ROBINSON, 1913

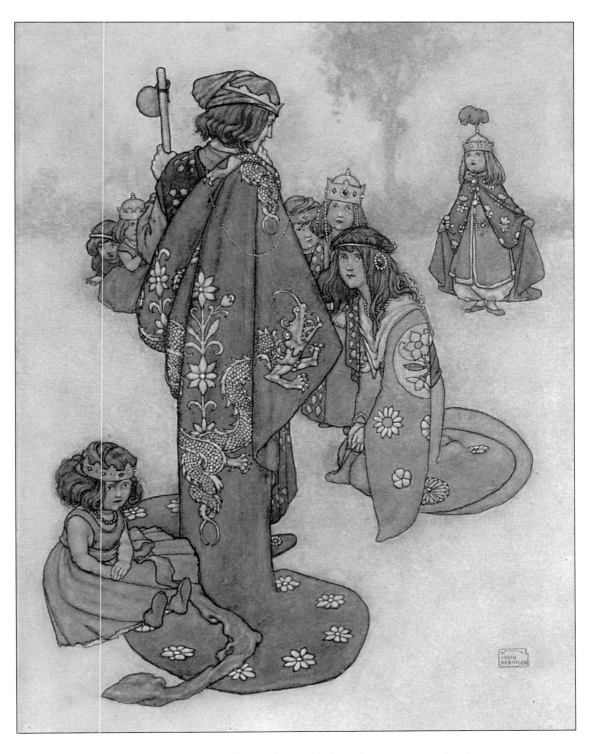

Princesses he found in plenty, but whether they were real princesses it was impossible for him to decide.

"The Real Princess," Hans Andersen's Fairy Tales
WILLIAM HEATH ROBINSON, 1913

The rich making merry in their beautiful houses, while the beggars were sitting at the gates
"The Happy Prince," *The Happy Prince and Other Tales by Oscar Wilde*
CHARLES ROBINSON, 1913

CHARLES ROBINSON, 1870–1937
The Happy Prince and Other Tales by Oscar Wilde, 1913

During the Golden Age of illustration, there was an interest in "new" illustrated stories, as well as the well-known tales of Grimm, Andersen, and Perrault. A small group of these "new" tales have become classics to us, a century later. For example, Oscar Wilde's collection *The Happy Prince* had been in print only a quarter of a century when Charles Robinson, William Heath Robinson's older brother, took it on as an illustration assignment in 1913—the same year that William produced images for the tales of Hans Christian Andersen. Charles's work here is decidedly more mature, better developed and refined than much of the work being done for comparable titles of the time. The middle son of the three Robinson boys, Charles had a strong career in illustration, creating art for more than sixty titles in a span of more than thirty years.

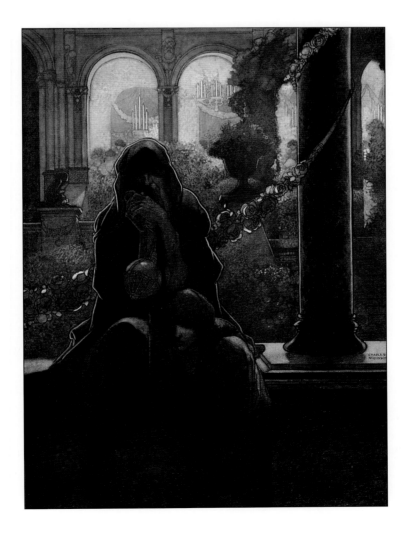

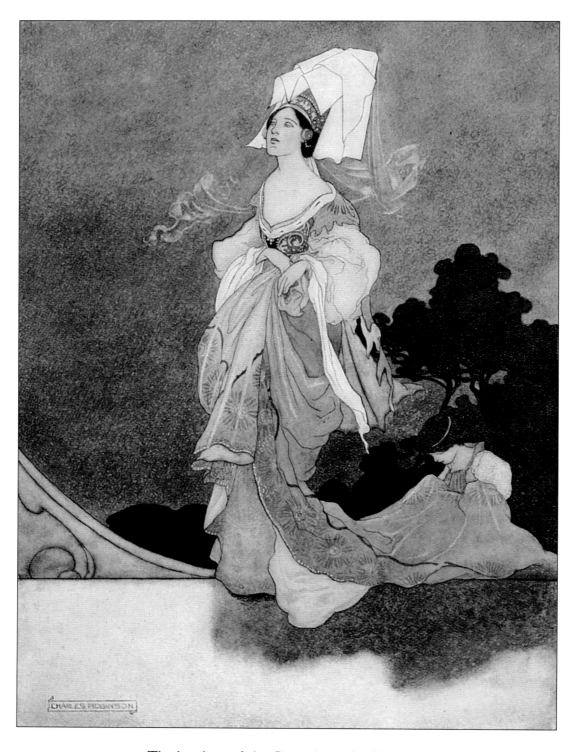

The loveliest of the Queen's maids of honour

"The Happy Prince," *The Happy Prince and Other Tales by Oscar Wilde*
CHARLES ROBINSON, 1913

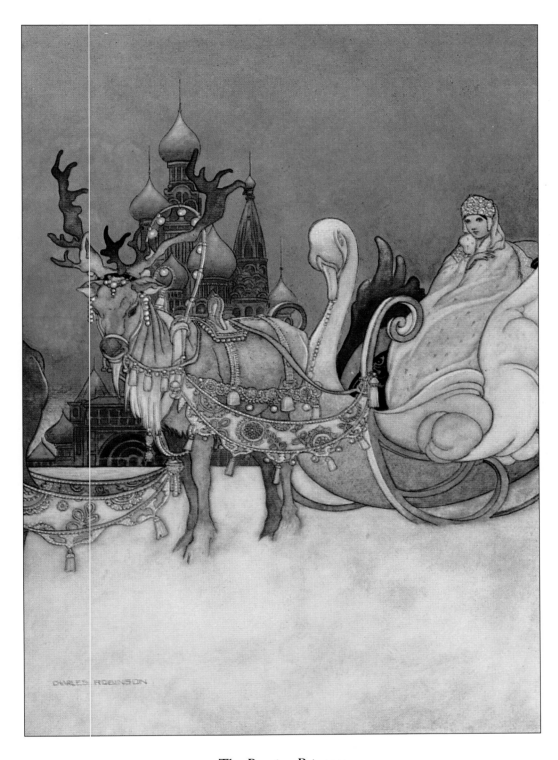

The Russian Princess

"The Remarkable Rocket," The Happy Prince and Other Tales by Oscar Wilde
CHARLES ROBINSON, 1913

"What a miserable creature I am!" sobbed the princess

"The Little Swineherd," *The Fairy Tales of Hans Christian Andersen*
HELEN STRATTON, 1899

HELEN STRATTON, ACTIVE 1891–1925
The Fairy Tales of Hans Christian Andersen, 1899

London-based Helen Stratton was considered to be at the peak of her career with her illustrations for a collection of fairy tales by Hans Christian Andersen. This work presented more than four hundred pen-and-ink illustrations by Stratton, ranging from small ornamental vignettes to complex full-page and multi-figure pieces. In many of these images, Stratton reveals the influence of the commercial work of the period, with Art Nouveau–inspired forms appearing within her imagery. Stratton produced illustrations for a number of well-received editions, including *The Arabian Nights*, George MacDonald's *The Princess and the Goblin* and *The Princess and Curdie*, and Jean Lang's *The Book of Myths*.

It was the old soldier

"The Red Shoes," *The Fairy Tales of Hans Christian Andersen*
HELEN STRATTON, 1899

"What's that?" said the woman, looking round

"The Ugly Duckling," The Fairy Tales of Hans Christian Andersen
HELEN STRATTON, 1899

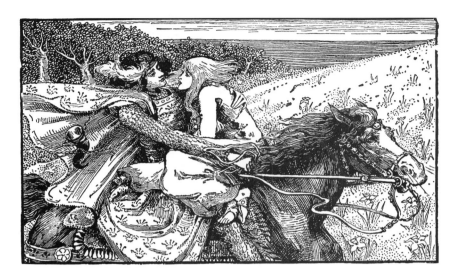

[The king] held her before him on his horse

"The Wild Swans," *The Fairy Tales of
Hans Christian Andersen*
HELEN STRATTON, 1899

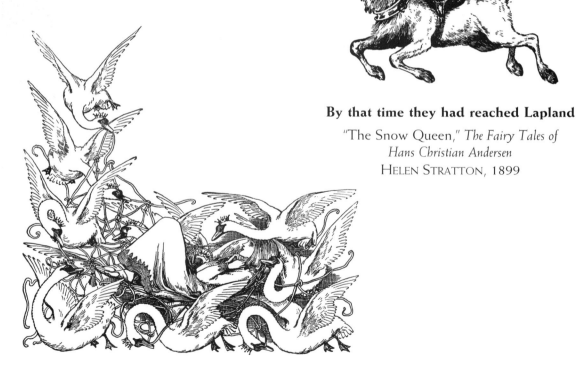

By that time they had reached Lapland

"The Snow Queen," *The Fairy Tales of
Hans Christian Andersen*
HELEN STRATTON, 1899

The swans carried Elise away from the rock

"The Wild Swans," *The Fairy Tales of Hans Christian Andersen*
HELEN STRATTON, 1899

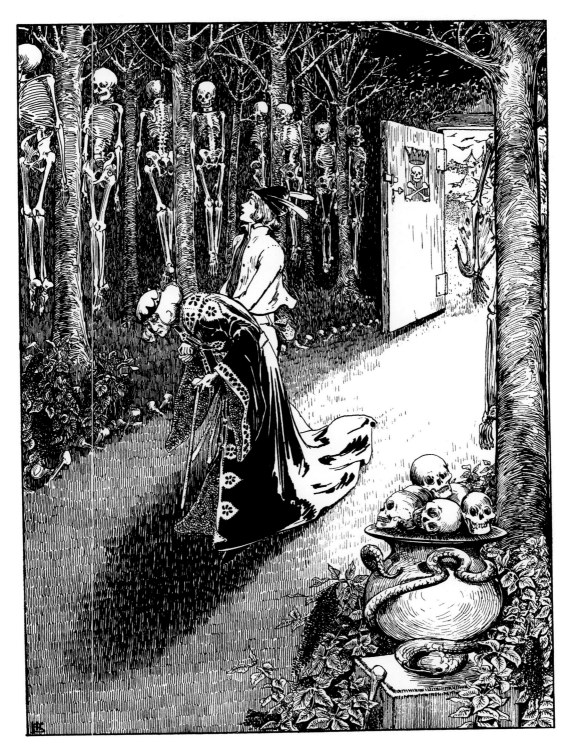

**From every tree hung three or four Kings' sons, who had wooed the princess,
but had been unable to guess her riddles**

"The Fellow-Traveller," *The Fairy Tales of Hans Christian Andersen*
HELEN STRATTON, 1899

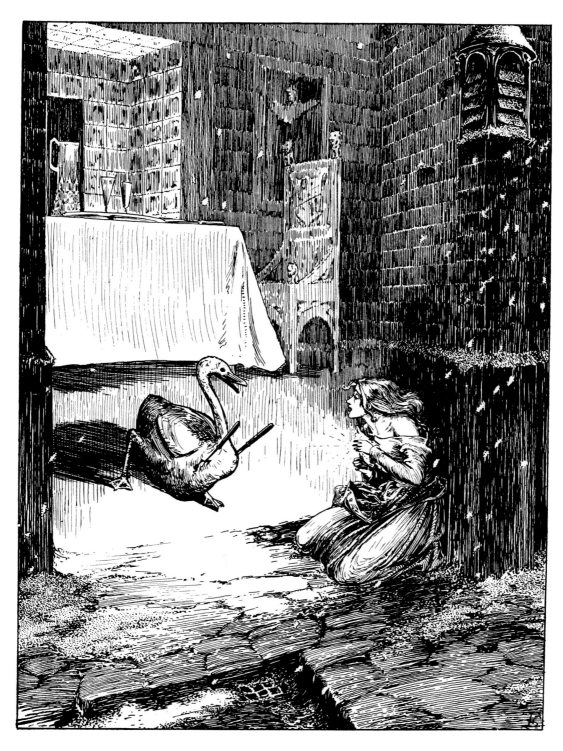

**And what was more delightful still, the goose jumped down from the dish,
and waddled along the ground, with a knife and fork in its breast, up to the poor girl**

"The Little Match-Girl," *The Fairy Tales of Hans Christian Andersen*
HELEN STRATTON, 1899

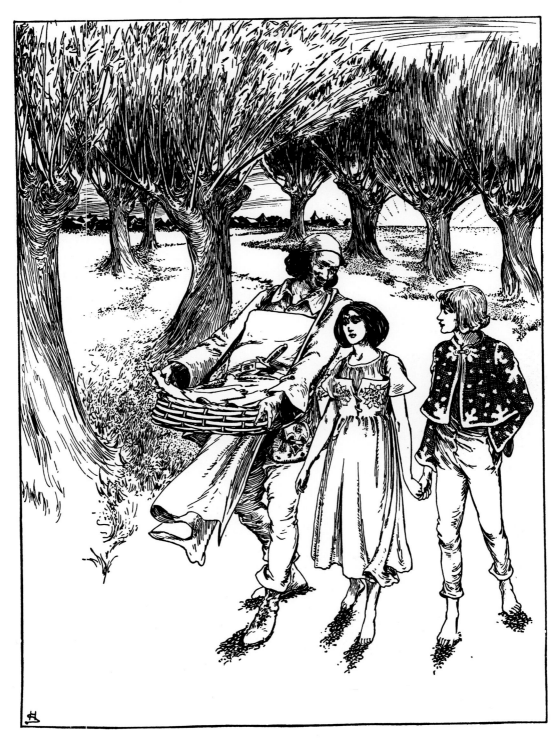

One evening he told a story . . . which greatly impressed them

"Under the Willow," *The Fairy Tales of Hans Christian Andersen*
HELEN STRATTON, 1899

HANS TEGNER, 1853–1932
Fairy Tales and Stories by Hans Christian Andersen, 1900

The stunning range displayed within the images by Hans Tegner presented here is unmatched for work by a single artist. Reflecting the experimentation being done in printing at the turn of the century, Tegner's illustrations are printed in a variety of dark colors, as well as being reproduced in a number of mediums. While most of these plates are engravings done after paintings, there are reproductions of line-art drawings as well. Tegner (1853–1932), a well-respected artist in his homeland of Denmark and a renowned illustrator of the works of Hans Christian Andersen, has had an influence on future generations of artists.

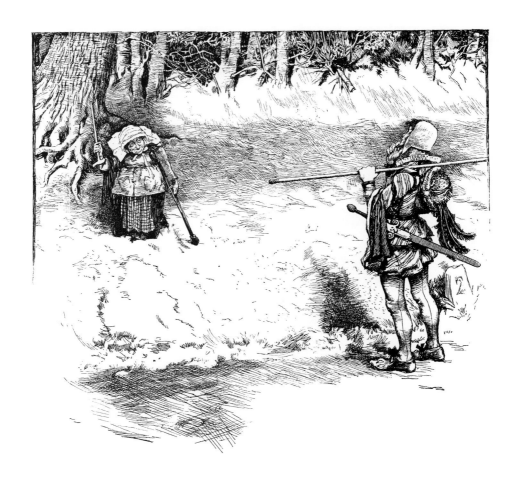

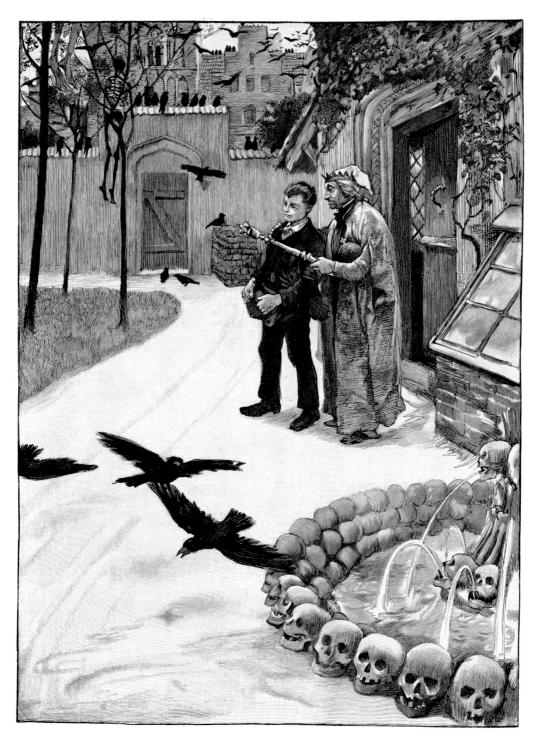

**The King led Johannes out into the Princess's garden. In every tree hung
three or four skeletons of princes who had wooed the princess**

"The Traveling Companion," *Fairy Tales and Stories by Hans Christian Andersen*
HANS TEGNER, 1900

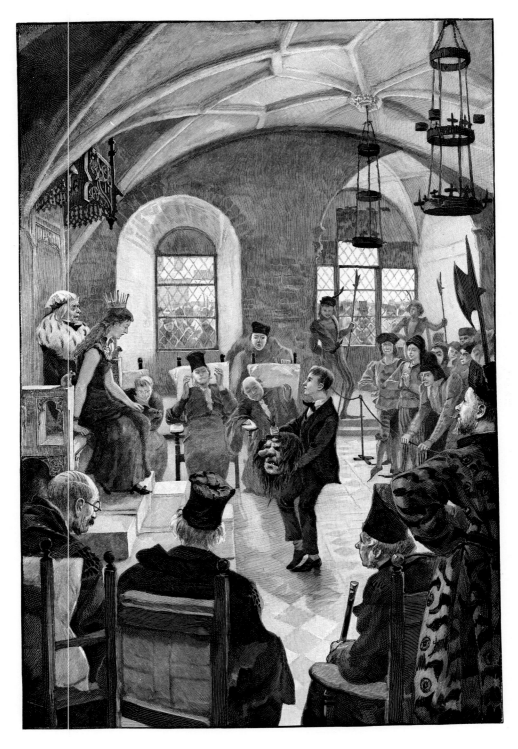

**Johannes untied his handkerchief and showed
the princess the ugly head of the troll**

"The Traveling Companion," *Fairy Tales and Stories by Hans Christian Andersen*
HANS TEGNER, 1900

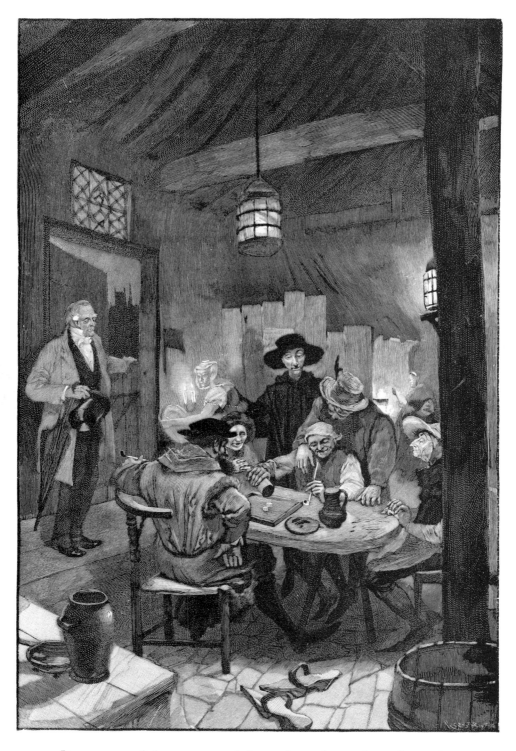

**It was one of the taverns of those days. A number of people,
consisting of skippers, citizens, and learned personages were sitting there**

"The Galoshes of Fortune," *Fairy Tales and Stories by Hans Christian Andersen*
HANS TEGNER, 1900

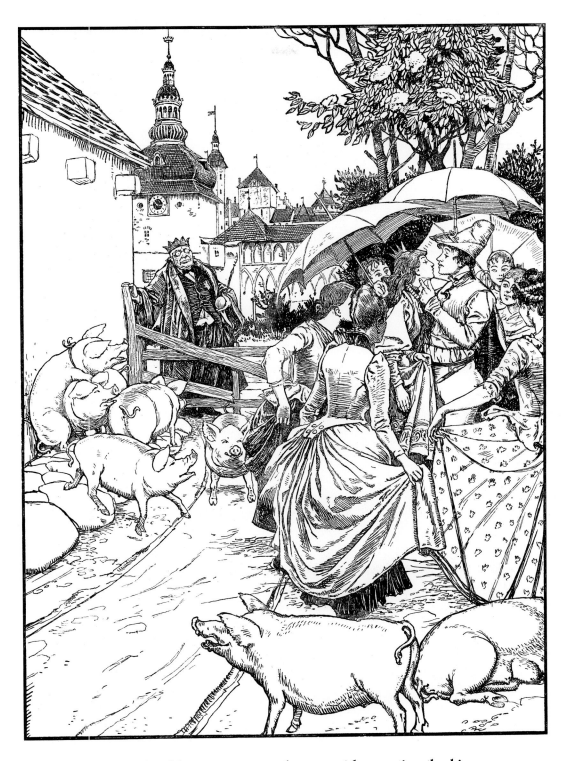

**The maids of honor were so taken up with counting the kisses
that they did not notice the emperor**

"The Swineherd," *Fairy Tales and Stories by Hans Christian Andersen*
HANS TEGNER, 1900

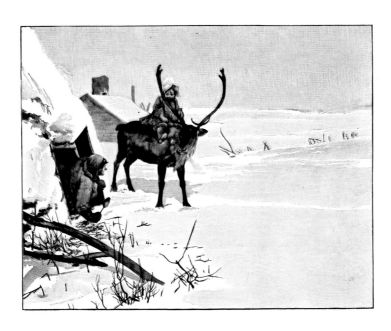

The Lapwoman and the Finwoman

"The Snow Queen," *Fairy Tales and Stories by Hans Christian Andersen*
HANS TEGNER, 1900

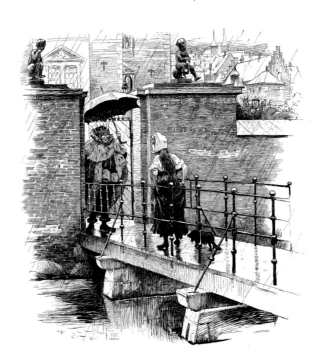

Headpiece

"The Princess and the Pea," *Fairy Tales and Stories by Hans Christian Andersen*
HANS TEGNER, 1900

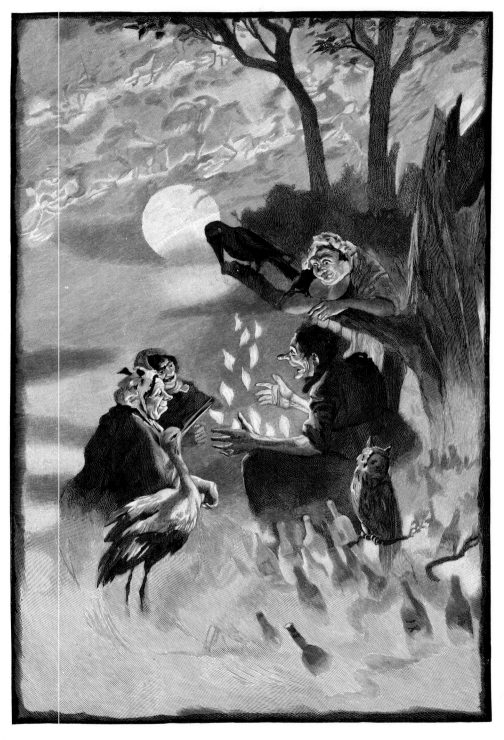

"I had all the twelve new-born will-o'-the-wisps in my lap," said the **Woman from the Marsh**

"The Will-O'-the-Wisps are in Town," *Fairy Tales and Stories by Hans Christian Andersen*
HANS TEGNER, 1900

**He perceived a horrible rock, as black as ink, and the next minute
one of the dragons casting out fire from his mouth**

"The Fair with Golden Hair," *D'Aulnoy's Fairy Tales*
GUSTAF TENGGREN, 1923

164

GUSTAF TENGGREN, 1888–1956
D'Aulnoy's Fairy Tales, 1923

The Swedish artist Gustaf Tenggren arrived late to the Golden Age of book illustration. When he entered the field professionally, he followed the lead carved by Rackham, Dulac, and the Robinson brothers. By the mid-1920s, however, the market for lavishly produced gift-books was beginning to wane. Tenggren sought out opportunities in a multitude of areas, including books, magazines, and advertising. In 1936 his talents were recognized by Walt Disney Studios; Tenggren was hired to work with on significant animated films, including *Snow White* and *Pinocchio.* After Tenggren left Disney, in 1939, his approach to illustration was much simpler, possibly due to his successful involvement with animation. Tenggren continued to flourish as a children's-book illustrator in the 1940s and '50s, but never returned to the rich complexity that he displayed in his earlier work.

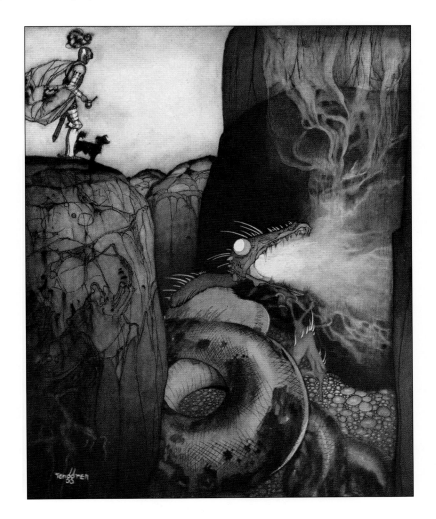

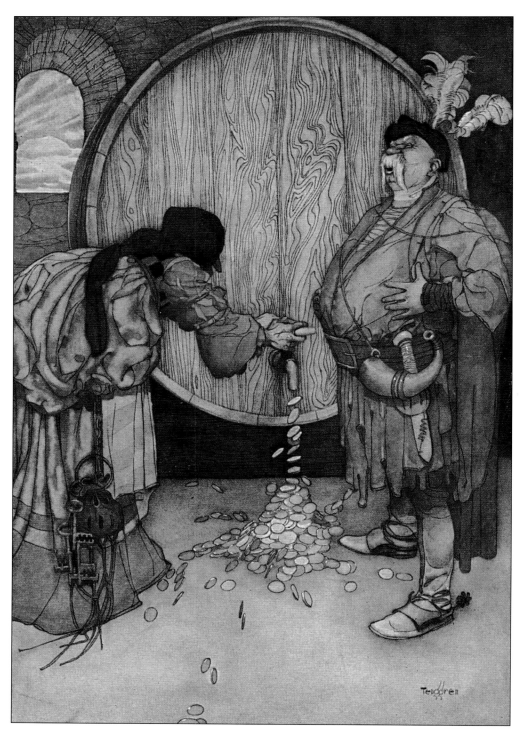

Somebody must have stolen my good wine and put in its place these trifles

"Gracieuse and Percinet," D'Aulnoy's Fairy Tales
GUSTAF TENGGREN, 1923

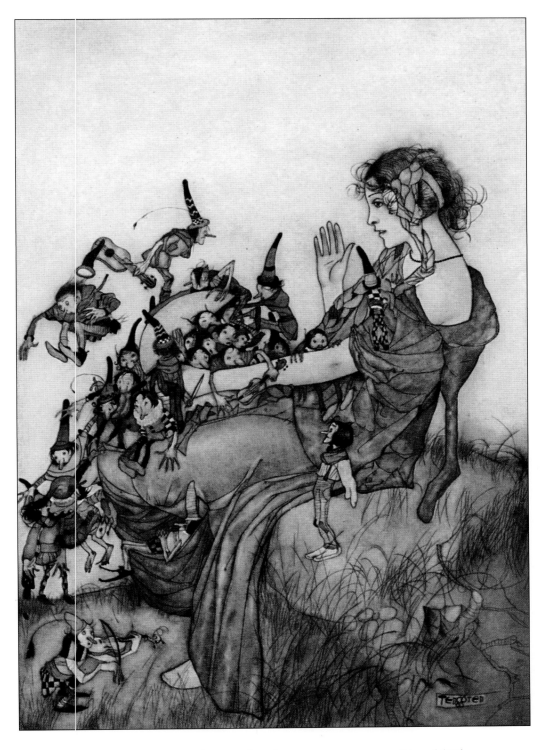

She opened the box and immediately out came a quantity of little men

"Gracieuse and Percinet," D'Aulnoy's Fairy Tales
Gustaf Tenggren, 1923

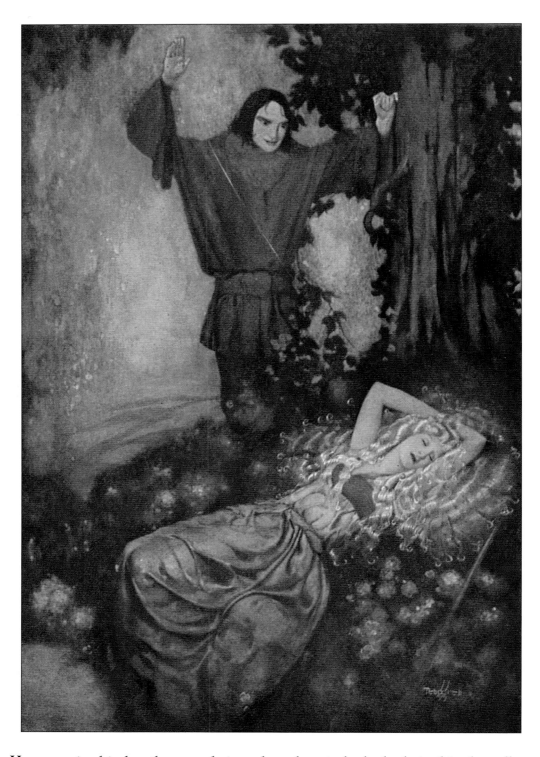

He recognized in her the same being whose beauty he had admired in the gallery

"The Golden Branch," D'Aulnoy's Fairy Tales
GUSTAF TENGGREN, 1923

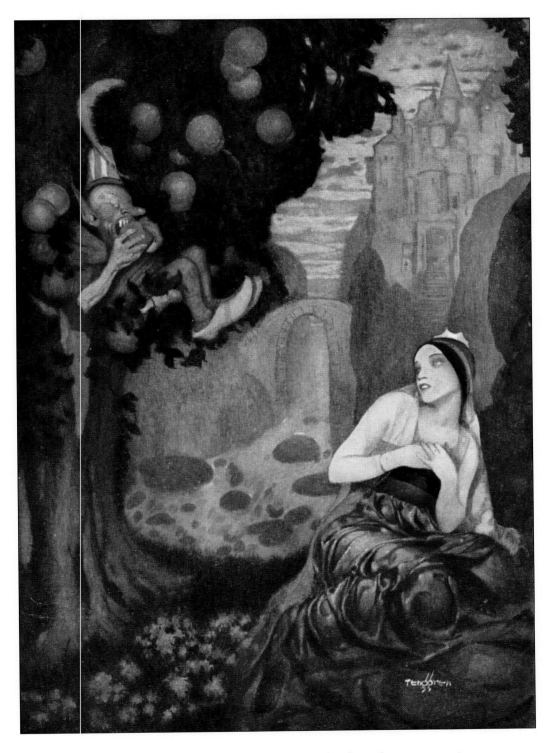

I know you well queen, and I know the fear that you are in

"The Yellow Dwarf," D'Aulnoy's Fairy Tales
GUSTAF TENGGREN, 1923

"Shall we exchange?" he said to the owner of the sheep
"Whatever the Old Man Does Is Always Right," *Hans Andersen's Fairy Tales*
MILO WINTER, 1916

MILO WINTER, 1888–1956
Hans Andersen's Fairy Tales, 1916

As an American illustrator who built up a long list of classic titles, Milo Winter produced work that had a more comic edge than many of his contemporaries; he also possessed a colorful palette and showed a real talent for storytelling. Originally from Princeton, Illinois, Winter attended the Chicago Art Institute and then went on to a long career in children's books. He is best remembered today for the work he did on the Rand McNally children's book line. These books contained scores of color illustrations, many embedded within the text, as well as larger plates. The Rand McNally series included *Aesop's Fables*, the *Arabian Nights*, *Alice in Wonderland*, and *Gulliver's Travels*. After a long and prolific career as an illustrator, Winter became an art editor for Childcraft in 1947.

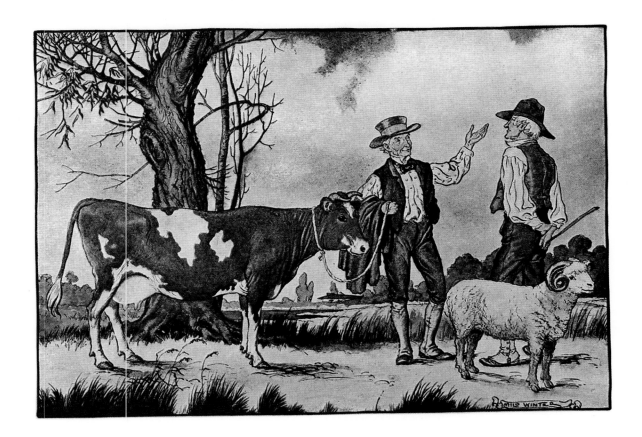

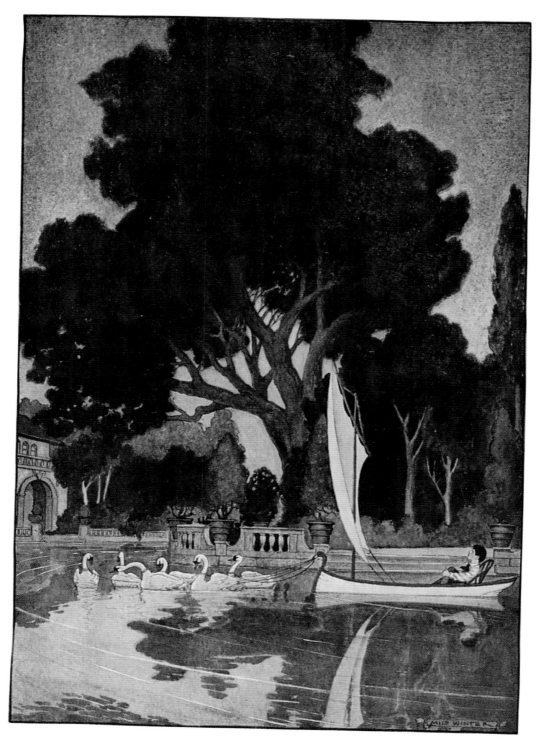

That certainly was a pleasure trip!
"Olé Luköié," Hans Andersen's Fairy Tales
Milo Winter, 1916

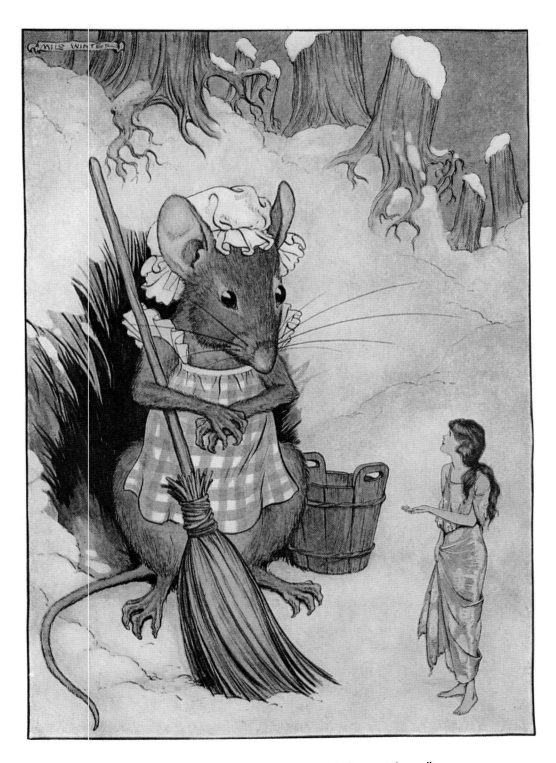

"Come into my warm room and dine with me"
"Thumbelina," Hans Andersen's Fairy Tales
Milo Winter, 1916

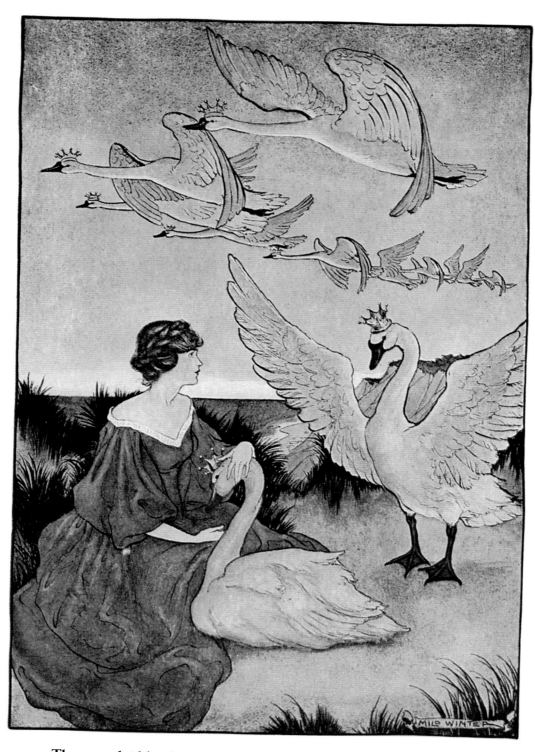

The swan laid his head in her lap and she stroked its white wings
"The Wild Swans," Hans Andersen's Fairy Tales
MILO WINTER, 1916

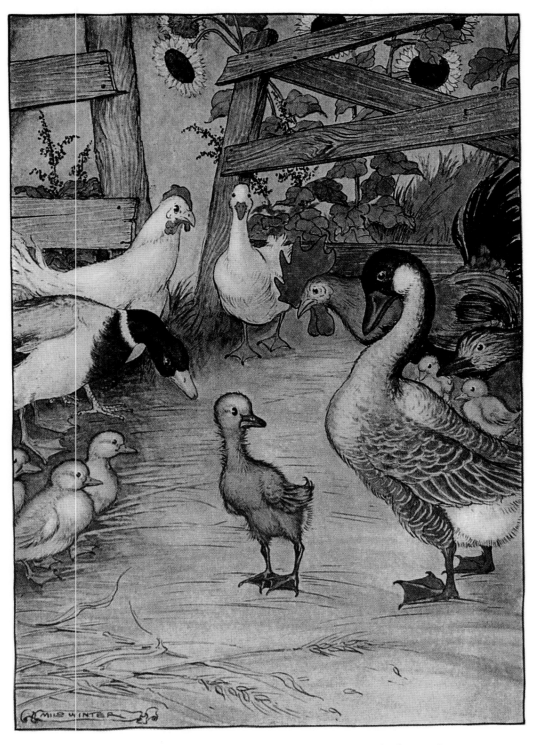

The poor Duckling was scoffed at by the whole yard
"The Ugly Duckling," Hans Andersen's Fairy Tales
Milo Winter, 1916

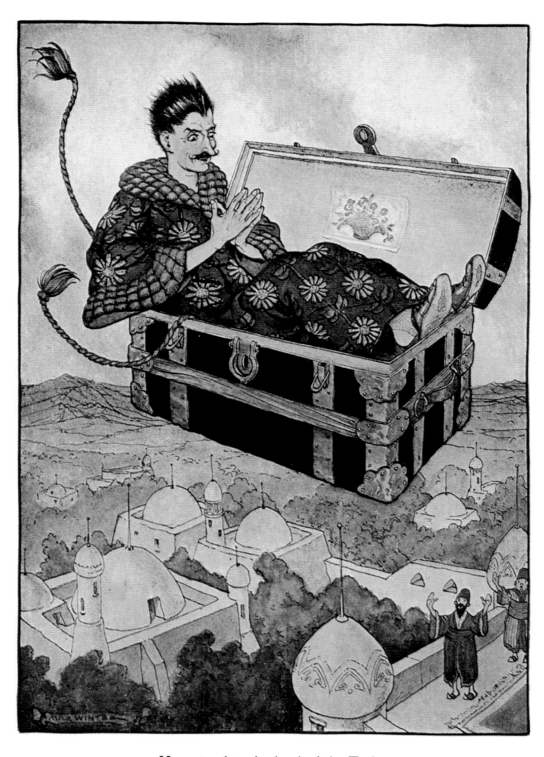

He arrived in the land of the Turks
"The Flying Trunk," Hans Andersen's Fairy Tales
MILO WINTER, 1916

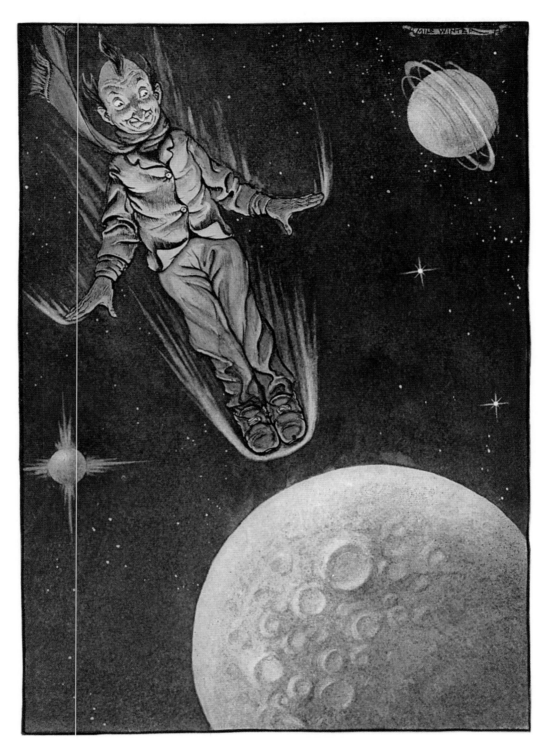

The Watchman traveled to the moon
"Fortune's Overshoes," *Hans Andersen's Fairy Tales*
Milo Winter, 1916